A–Z

OF

NORTHWICH & AROUND

PLACES - PEOPLE - HISTORY

Adrian L. Bridge and Dawn Preece

AMBERLEY

First published 2019

Amberley Publishing
The Hill, Stroud, Gloucestershire, GL5 4EP
www.amberley-books.com

Copyright © Adrian L. Bridge and Dawn Preece,
2019

The right of Adrian L. Bridge and Dawn Preece
to be identified as the Authors of this work
has been asserted in accordance with the
Copyrights, Designs and Patents Act 1988.

ISBN 978 1 4456 9259 3 (print)
ISBN 978 1 4456 9260 9 (ebook)

British Library Cataloguing in Publication Data.
A catalogue record for this book is available
from the British Library.

Typesetting by Aura Technology and Software
Services, India. Printed in Great Britain.

Contents

Introduction

In some ways, the history of Northwich could be summed up by the three 'S's – salt, soda ash and shipbuilding. The impact of the salt industry, over nearly 2,000 years, has obviously been immense. Indeed, the very name 'Northwich' is indicative of the town's strong links with salt. The 'wich' part of the name is thought to derive from the Norse word *wic*, which meant 'bay', and a bay was the traditional area in which salt could be obtained via the evaporation of seawater. Over time, the place where salt was made became known as a 'wich' house, and Northwich was the most northerly of the Cheshire 'wich' towns.

In later centuries, the soda ash and shipbuilding industries also helped transform the town into a major centre of industrial and commercial activity. In the pre-industrial age, Northwich was tiny, encompassing little more than 6 statutory acres of land centred on the area that is now the Bull Ring, surrounded by other small townships such as Leftwich, Witton-cum-Twambrooks and Rudheath. Over the centuries, aided by the significance of the salt industry, Northwich expanded outwards to incorporate many of these nearby townships and villages, and the modern town of Northwich now stretches for a good few miles out into the Mid Cheshire countryside.

This is an A–Z look at Northwich and the surrounding areas, which takes into account the very close historic links between the old miniscule town of Northwich and its nearby parishes and villages. It's also a history that is about much more than just the industries that shaped the area. It's about the people, past and present, who have had a significant connection with the locality and who've gone on to achieve great things (in whatever sphere). Some of these people will be familiar to readers, and are referred to frequently during the course of this book. Other people included will not be so well known. This book also looks at a range of buildings and places of interest in the area, from the iconic timber-clad, black and white buildings of central Northwich to the open spaces of Delamere Forest and the Gothic design of Arley Hall. Given the format of the book, it's only been possible to develop some points to an introductory level. We do, however, hope that by reading *A–Z of Northwich & Around* we inspire people to discover more about the intriguing history, people and places of interest in this magnificent part of Cheshire.

Allen Sisters

The Allen family first became associated with Northwich when Russell Allen, the owner and proprietor of the *Manchester Evening News*, bought the neoclassical Georgian Davenham Hall, just off London Road in the parish of Davenham, in 1909. He was a regional newspaper magnate of considerable repute, and the Allen family were right at the top of Manchester society and key members of the local and national Liberal Party. When he sold the *Manchester Evening News* to the *Guardian* in 1927, he created the genesis of the modern Guardian Media Group, which is still a major player in the newspaper and media world of today. Three of his daughters, Doris, Geraldine

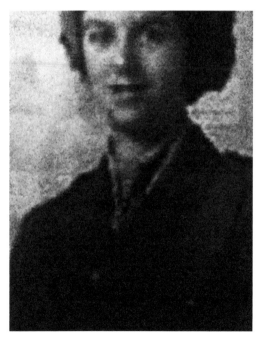

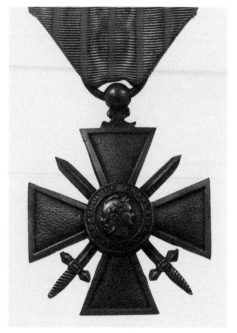

Above left: Doris Allen in FANY officer's uniform *c.* 1917.

Above right: French First World War Croix de Guerre medal. (Courtesy of Bjorn Torrissen)

and Margaret, would spend the rest of their distinguished (if now largely forgotten) lives living at Davenham Hall. Doris and Geraldine served on the Western Front in the First World War in the First Aid Nursing Yeomanry and Doris was awarded the French *Croix de Guerre* gallantry medal, with Bronze Star, for her actions on the Marne in 1918. Here, during the last German offensive of the war, Doris played a major part in processing 17,000 French and Allied casualties, in just five days, through the town of Epernay. Both Doris and Geraldine Allen also received the commemorative *Medaille de Societe aux Blesses Militaires* (the forerunner of the French Red Cross) for their wartime services. After the war, all three sisters became enthusiastic supporters of Chester Zoo. During the Depression years of the early 1930s the zoo became perilously short of money, and the *Liverpool Post* announced, in May 1934, that unless more money was found the zoo would close within four days. A great appeal was launched and Geraldine Allen, supported by her sisters, became one of the zoo's greatest benefactors. Geraldine was appointed as one of the three directors of the North of England Zoological Society, which managed Chester Zoo from 13 June 1934 onwards, supported by an elected council of twenty-one members. Chester Zoo's first aquarium was funded entirely by Geraldine. Doris Allen gave the zoo its first ever pair of penguins, and the Allen sisters also presented the zoo with a pair of orphan lion cubs in January 1935. It was Geraldine

Geraldine Allen (second from left) at the opening of Chester Zoo's lion enclosure in 1947. (© George Williams)

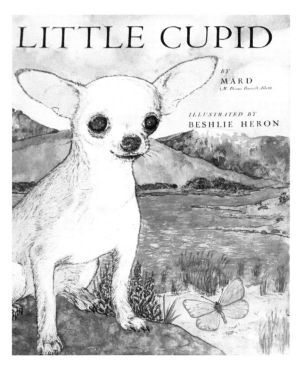

Front cover of *Little Cupid* book, presented to the granddaughter of the founder of Chester Zoo by Geraldine Allen. (© Jo Williams)

Allen, however, who devoted the most time and energy to the development of the zoo. She attended zoo council meetings, assiduously, for nearly forty years, and when these meetings were held in the evenings council members' children would all be taken to Chester's Majestic Theatre, at Geraldine's expense, and treated to ice cream and sweets. Margaret Allen went on to write children's books, under the pseudonym 'Mard'. One of these books was a rather beguiling fairy story called *Many Moons*, which was about a small white chihuahua. Another story called *Little Cupid* also features a white chihuahua. In fact, all three sisters were renowned chihuahua breeders and played a significant role in national Kennel Club politics, helping to launch a breakaway northern Chihuahua Club in the 1950s. All three sisters remained unmarried. Margaret was the first of the three sisters to pass away, in 1974, and Geraldine followed in 1978. Doris, the elder sister, lived the longest, and finally passed away in 1979, marking the end of nearly seventy years of continuous Allen family occupation of Davenham Hall. The hall was sold the following year, and after a period of refurbishment, the building was reopened as a nursing home – a function it still holds today.

Anderton Boat Lift

The Anderton Boat Lift in Lift Lane, Northwich, was a masterpiece of Victorian engineering, often described as being the 'Cathedral of the Canals'. At the request of the trustees of the Weaver Navigation, the boat lift was designed by Edwin Clark in

1875 and actually built by Emmerson & Murgatroyd of Stockport, at a total cost of over £48,000. The new construction was designed to solve the problem of transporting goods from the River Weaver to the Trent & Mersey Canal (and vice versa). The gap between the two waterways was roughly 50–60 ft, and prior to the boat lift's construction, goods were transferred in a slow and time-consuming way, either manually or via shutes. The lift was designed to speed up the time it took to move goods from the river to the canal, and it did this in spectacularly successful fashion. At the height of its usage, the Anderton Boat Lift could lift and lower sixteen boats an hour, and it took around 150 seconds to either ascend or descend in the lift. In 2018, the same procedure takes around 30 minutes to complete! During the course of its history from 1875 until the present day, the Anderton Boat Lift has been through three main phases. Between 1875 and 1908, the lift operated on quite simple but very effective hydraulic principles. Two huge watertight caissons were attached to metal shafts that were embedded deep into the bed of the River Weaver. An empty caisson weighed 90 tons, and a caisson full of water weighed 252 tons. When barges were placed in the caissons, water displacement and gravity itself assisted in ensuring either the ascent or descent of the boat. The new hydraulic boat lift was certainly a massive success in increasing the level of trade between the Weaver and the Trent & Mersey. In its first year of operation, in 1876, the lift shifted 31,000 tons of goods, but by 1906 this figure had risen to over 192,000 tons. However, the hydraulic lift still had its difficulties. The corrosive effects of salt, water and general pollution brought about increasing mechanical problems. The lift was more prone to breaking down, and to increase efficiency and reliability the 'Cathedral of the Canals' became electrically operated in July 1908. The new electric-driven lift was designed by John Saner at a cost of £25,000. The construction increased in size by 20 feet in order to accommodate all the extra cables and electrical fittings necessary, and it continued in use, with relatively few

Anderton Boat Lift.

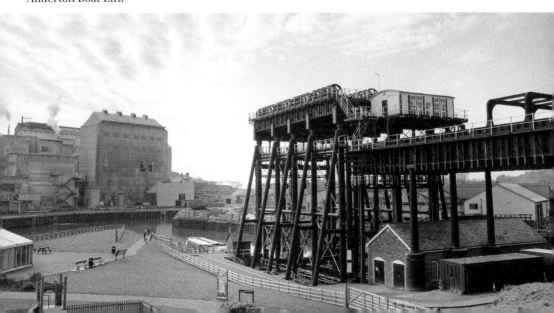

interruptions, until corrosion forced the closure of the whole boat lift in 1983. The Anderton Boat Lift remained neglected and derelict for the next sixteen years. By 1999, however, campaigners had successfully secured over £7 million in funding for the restoration of the boat lift, and in 2002 it was reopened, with much fanfare, to begin its third and current incarnation as both a major tourist attraction and a working boat lift. The Anderton Boat Lift has gone back to operating on its original hydraulic principles, but controlled via digital technology from a central control room. Judging from the figures, the restored boat lift certainly has a promising future. In 2018, over 120,000 people visited the attraction, and 3,500 boats used the lift itself.

Arley Hall

Arley Hall lies a short distance to the north of Northwich town centre, within the parish of Arley. The house is a Grade II listed building, constructed between 1832 and 1845 in order to replace an earlier property. Although built in the late Georgian/early Victorian period, the architect, George Latham, designed it in Jacobean style. The famous gardens were also developed at roughly the same time, in the 1830s, but matured majestically during the course of the twentieth century. The gardens contain one of the first, and still one of the finest, herbaceous borders to be seen anywhere in Britain. Open to the public since the 1960s, it has been part of the land owned by the Cheshire Warburton family since the twelfth century. Its current owners, Lord and Lady Ashbrook, still reside at the hall, which houses food fairs and other major events. It's been used as a location for TV productions such as *Peaky Blinders*, *The Adventures of Sherlock Holmes* and episodes of *Coronation Street*.

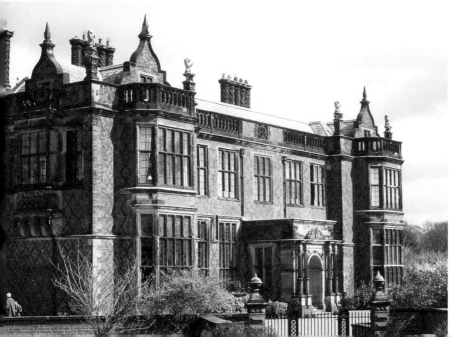

Arley Hall. (Courtesy of Peter I. Vardy)

B

Gary Barlow

Gary Barlow was born a few miles to the west of Northwich, in Runcorn, on 20 January 1971. He seems to have been destined for a musical career from an early age, learning to play the keyboard at ten and reaching the semi-finals of a BBC *Pebble Mill at One* Christmas songwriting competition when he was only fifteen. Since that time, Gary Barlow has achieved worldwide fame as lead singer of the band Take That, and as a solo singer and songwriter. Gary used some of the wealth he acquired from his vast music interests to buy the substantial Delamere Manor in Cuddington, Northwich, where he lived for ten years between 1996 and 2006. The substantial manor house with well over 100 acres of land was once the family seat of the powerful Cheshire Wilbraham family, but Gary imbued the property with his own personality by instituting a series of changes such as trailing bougainvillea painted down a corridor running from the entrance hall to the kitchen. There was also a traditional frieze on

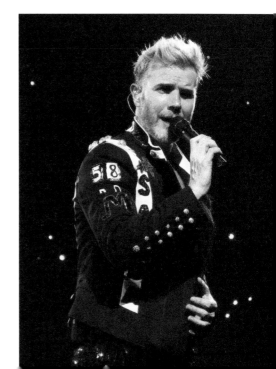

Gary Barlow in concert, Glasgow, May 2017.
(© Marc E)

the ceiling of the master bedroom, and a meditation room and recording studio were also installed at the property. These alterations and improvements were supervised by Gary Barlow's elder brother, Ian. Meanwhile, Gary's parents, Colin and Marjory, also moved onto the estate, occupying the gatehouse. Here, Gary's mother kept 200 chickens, and sold the resultant eggs outside the gates of the estate, with the aid of a courtesy box. Just outside the estate, during the height of the Take That craze, female fans kept up a twenty-four-hour watch, cheering and screaming as Gary and others entered and exited the house and grounds. Although Gary sold the property in 2006, and his parents moved back to Frodsham, he retains strong family links with Cuddington and Northwich. His brother Ian continued to live in Cuddington, very near to Delamere Manor, long after Gary Barlow had finally relinquished the property and moved to West London.

Barons Quay

Most Northwich people will have heard of, and visited, the new multimillion-pound retail and leisure development in the centre of the town. Construction work on the new commercial hub, designed to attract visitors from the immediate region and beyond, only finished in November 2017. Even so, a supermarket, restaurants and a cinema are already based at the location, and a range of other popular brand outlets seem set to follow. As people shop, eat and spend their leisure time at the new development, possibly only a minority really understand the history of Barons Quay and, more particularly, the significance of what once lay beneath their feet, because Barons Quay was once the home of the largest rock salt mine in central Northwich. A small, rather faded stainless steel plaque on the side wall of the current Marks & Spencer store commemorates the fact that a huge Victorian salt mine once lay roughly 300 feet beneath its present foundations. This was the immense Barons Quay Mine, which operated from the early 1850s onwards, until its closure in February 1906. During this time, well over half a million tons of rock salt was extracted from Barons Quay Mine, and at its height probably sixty people or so were employed by the company. The Barons Quay Mine was a massive business, utilising (by the 1880s) electric lighting and some of the latest cutting machinery and technology. By the time Barons Quay Mine closed in 1906, salt extraction had led to the creation of huge empty spaces (or voids) below ground. In the case of Barons Quay Mine, these voids covered around 25 acres of subterranean earth, which was added to by the voids caused by the three nearby mines of Witton Hall, Neumann's and Penny's Lane. Even though some early attempts were made to infill these voids, huge problems were being caused, and by the 1990s local council officials announced that the town of Northwich was in danger of sinking into the four old mines below. In order to prevent the town from sinking so disastrously, the Northwich Stabilisation Project was launched, which was the largest project of its type undertaken anywhere in the world at that time.

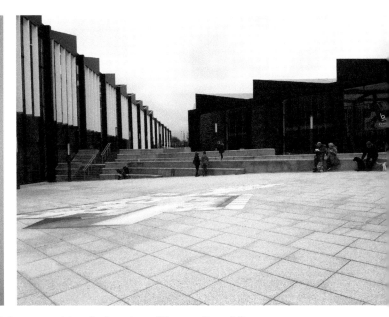

Barons Quay Mine

[Su]permarket occupies [sit]e of the former Barons [Quay] Mine from which rock [salt] was mined between [cir]ca 1850 and 1906. [The] two mine shafts are [loca]ted beneath this wall [and] gave access to the mine workings [app]roximately 300 feet below.

Above left: Transcription of plaque marking the location of Barons Quay Mine.

Above right: Barons Quay viewed from Leicester Street.

Barons Quay was at the centre of these endeavours. In all, nearly 1 million tons of pulverised fuel ash (a waste product generated by power stations) was pumped into the Barons Quay, Penny's Lane, Neumann's and Witton Hall voids, along with 30 tons of cement. This new material filled voids equivalent in size to 320 Olympic-sized swimming pools. The stabilisation process was largely completed by the end of 2007, at a cost of approximately £30,000,000. Once the centre of Northwich was freed from the danger of sinking, planners could concentrate on the development of Barons Quay leisure and retail facilities – a development only made possible by the successful completion of an engineering project that attracted worldwide attention.

Bratts

At one time or another most of the town's current residents will have seen, visited and probably bought items from Northwich's oldest retail business, which has been based at roughly the same location, on Witton Street, for the best part of 160 years. The original store was called The Arcade when it began in 1860, and traded under the name H. Bratt & Son. In the very early days of the shop, the owner, Henry Bratt, made some useful profits by the rather ingenious method of providing customers with credit in return for shares in the newly formed chemical company Brunner Mond. The shop clearly did well and, together with a number of other leading local businesses, it helped pioneer the use of electric lighting during the evenings in the late

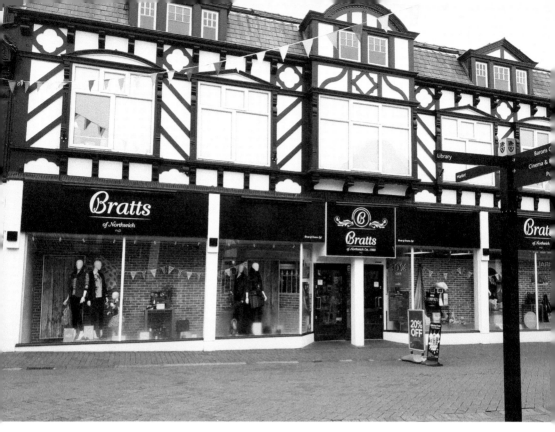

Bratts, Witton Street.

1890s. Henry Bratt was predeceased by his son, Miles, which seems to have been the catalyst for Henry to withdraw from actively running the department store, in order to focus on a new life involving world travel and residency in Southport. In any event, by this stage Henry had acquired a fabric buyer called Jack Evans as his partner, and the store was henceforth known as Bratt & Evans. Jack Evans continued as the hands-on director of the enterprise until he sold the business to John Arthur Gray in 1928. The store has been in the hands of the Gray family ever since.

Sir John Tomlinson Brunner

J. T. Brunner was born in Liverpool in 1842 to a Swiss Unitarian father and an English mother. John Brunner entered the world of commerce at the tender age of fifteen, and in 1861 he went to work at Hutchinson's alkali works in Widnes, where he became the company's general manager. It was here at Hutchinson's that he met his future business partner, Ludwig Mond. In 1873, they both set up a new soda-ash-producing plant at Winnington, Northwich, and the Brunner Mond chemical empire was born. John Brunner became one of the great Victorian industrialists. He acquired fabulous wealth, and he used these resources to fund scholarships, education, buildings and other infrastructure in Northwich, Liverpool, Runcorn and elsewhere. In 1885, he became Northwich's first MP. He subsequently was knighted, and became a baronet

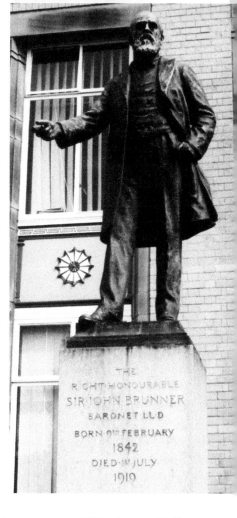

Statue of Sir John Tomlinson Brunner. (Courtesy of Salinae)

in 1895. The Brunner family lived for many decades in one wing of Winnington Hall, Northwich, while his partner, Ludwig Mond, lived in the other wing. When his first wife, Salome, died, Brunner married Jane Wyman, governess to his six children. Sir John Brunner and Jane remained married for over thirty-five years, until Jane's death in 1910. Brunner himself died in 1919, leaving an estate valued at £906,000. Sir John's descendants by his first wife, Salome, married into British and European royalty. His great-granddaughter, for example, is the current Duchess of Kent and one of his granddaughters, Shelagh, married into the royal House of Liechtenstein.

Bull Ring and the Angel

The Bull Ring was once at the centre of 'old' Northwich, long before the Industrial Revolution, when the town consisted of little more than a few 'wich' houses and worked salt pans in and around the confluence of the River Weaver and the Dane. The grizzly spectacle of bull-baiting was also a reasonably commonplace activity at the Bull Ring, where markets were also held from at least the late Tudor period onwards. In 1790, the Angel Hotel was constructed on a site formerly occupied by the

Left: The Bull Ring viewed from the NatWest building.

Below: The Angel Hotel, 1920, showing the effects of flooding and subsidence. (© Weaver Hall Museum)

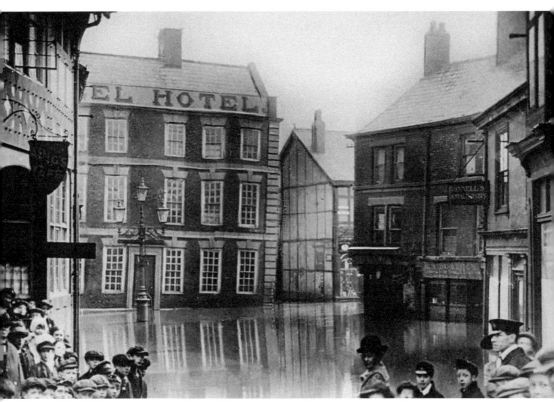

Angel public house. With its impressive Georgian façade, the Angel soon became the central distinguishing feature of the Bull Ring, and the most prestigious hotel in the town. Local gentry would visit the Angel, and industrialists and salt magnates from Brunner Mond and the Salt Union would hold their meetings at the hotel. Even Princess Victoria stayed at the establishment for a short while in 1835 – two years

prior to becoming queen. Events of national significance, such as the accession of Edward VII as King Emperor in 1901, were also announced to crowds assembled outside the hotel. The splendour and prestige of the Angel Hotel was not to last, however. During the 1890s, the Angel building repeatedly fell victim to the effects of subsidence, and in 1922 the whole grand Georgian edifice was demolished.

Tim Burgess

Tim Burgess, lead vocalist and songwriter of the successful indie band the Charlatans, was born on 30 May 1967 in Salford, Manchester, but spent most of his childhood in the parish of Moulton, Northwich. As a teenager, he used to walk from Moulton into the centre of Northwich and visit the Omega Records shop in Witton Street. In fact, the Omega was where he used to meet the other original members of the band. Between 1990 and 2003, Tim had a long and successful career with the Charlatans, although there were several band member changes. He lived in Los Angeles between 2004 and 2012, and his debut solo album came out in 2003, followed by a second solo album in 2012. In 2017 he returned to England for the release of the Charlatans' thirteenth album, *Different Days*, and in 2018 they did a 'one-off homecoming' gig in Northwich, which was highly successful. In early 2019, Tim also made his acting debut, starring in a short film called *The Bookshop*, which was directed by television and film actress Susan Lynch. In the film Tim plays a rather repressed bookshop owner called Leonard, who daydreams about the lives led by his customers.

Tim Burgess at the Salon Livres et Musique, Deauville, 2014. (© Coupdoreille)

Chemistry that Changed Northwich

Sodium carbonate, otherwise known as soda ash, was a white alkaline substance of major importance in the development of the Industrial Revolution in Britain. In the areas of Cheshire just to the west of Northwich, centred on the towns of Widnes and Runcorn, soda ash was a particularly crucial ingredient used in the making of soap. Manufacturers like Hutchinson's of Widnes relied on the Leblanc process, developed by Frenchman Nicolas Leblanc in 1791, to make soda ash, which could then be used to create soap, glass and other related products. The Leblanc industrial process,

Below left: Statue of Nicholas le Blanc in the Rue Saint Martin, Paris. (Courtesy of Mosset)

Below right: Ernest Solvay *c.* 1900.

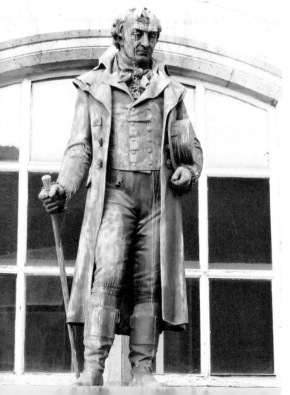

though used almost universally, was messy and time-consuming, using coal, lime, salt and sulphuric acid. The process also led to the creation of foul by-products such as hydrogen chloride gas. This wasteful old-fashioned process was superseded by a simpler, less wasteful method of soda ash production largely pioneered by the Belgian chemist Ernest Solvay in the early 1860s. The new, simpler Solvay process, also reliant on lime and salt, greatly interested the German chemist Ludwig Mond and John Brunner, who were both working at Hutchinson's in Widnes. In 1872, Mond travelled to Charleroi, Belgium, to visit Ernest Solvay's chemical plant and to acquire the commercial rights to use the process in the UK. He was totally successful in this plan and Mond and his partner began the development of their own British Solvay plant at Winnington Hill, Northwich, during the following year. Between 1873 and 1880 Mond carried out further refinements to the Solvay process, which made the production of the vital soda ash even more streamlined and efficient. By 1880, Mond and Brunner had made the Solvay process the most economically viable method of producing soda ash in existence. Not surprisingly, therefore, by the end of the nineteenth century Brunner Mond was by far and away the largest chemical company in the country. For hundreds of years Northwich had been a salt town, but largely as a consequence of the Solvay process, it had been transformed within the space of a few years into an internationally recognised centre of the chemical industry.

Mary Cholmondeley

Mary was born in Great Budworth in 1562. She was only nineteen when she was married for the second time, to Sir Hugh Cholmondeley, and they went on to have eight children together. She came to prominence during her lifetime as a result of one of the longest battles in English legal history, concerning the estate of her father George Holford, who died in 1581. Property rights for women in the sixteenth and seventeenth centuries were extremely limited. Even so, she fought her brother in the legal courts for over forty years in order to claim property rights left to her in her father's will. Eventually, in 1620, she agreed on a satisfactory settlement and was given her father's property at Holford Hall, just west of Plumley. She became a substantial property owner in her own right and purchased the Vale Royal Abbey estate, which had once been a medieval Cistercian abbey, founded by Edward I in 1270. The abbey was dissolved by Henry VIII in 1538, at which time much of the property was demolished. However, some of the cloister buildings survived and were added to by subsequent owners. Mary Cholmondeley certainly engaged in a partial rebuilding programme, and she then entertained James I and his entire court at the estate for three days in 1617. King James called her the 'bold lady of Cheshire' after she turned down his offer to advance the political careers of her sons. She continued to live at Vale Royal Abbey until her death in 1625.

Vale Royal Abbey (front view).

Aubrey Crowe and the Albemarle

On 15 April 1944, RAF Albemarle bomber V1609, based at Operational Training Unit No. 42 at Ashbourne, Derbyshire, hit the chimney stack of a building in the centre of Hartford village and crashed into the wall of Grange Farm, opposite a row of shops on Chester Road. Sadly, all but one of the five-man crew were killed. Given the proximity of the crash site to the centre of Hartford village, it was extremely lucky that no civilians were killed or injured, in addition to the unfortunate RAF personnel. It was characteristic of the nature of crews in Bomber Command that the doomed plane had Canadians and South Africans on board. As a whole, during the Second World War 25 per cent of Bomber Command personnel were from countries of the British Commonwealth and Empire. In addition to the Empire crew, Albemarle V1609 also contained one very local representative, Sergeant Aubrey Gerald Crowe, who was born in Hartford in 1910 and whose wife, Margaret, and five-year-old child, Peter, actually lived only a few doors away from the crash site. Sergeant Crowe (or 'Gerry' as he liked to be called) was one of those killed in the accident – only the gunner, who was flung clear in his turret as the plane hit the ground, actually survived. The fact that Gerry was a local boy has led some

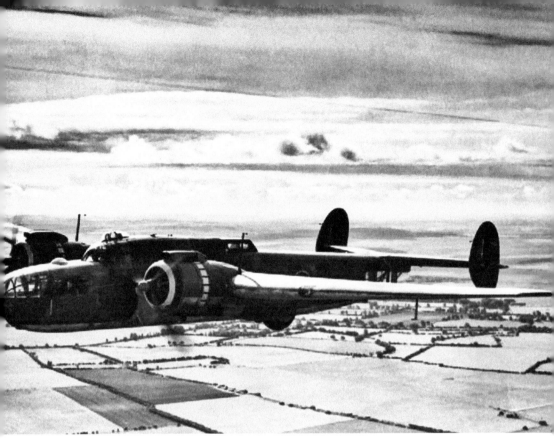

Armstrong Whitworth Albermarle Mark I, Series 2, 511 Squadron RAF, 1942.

to speculate that he and the crew were actually engaged in 'buzzing' Margaret and her child, at low level, while involved in their training activities. It seems the plane might have been as much as 50 miles off course at the time of the crash, which might indicate that Gerry and the crew were performing some sort of aerial 'hello' for the mother and son below. Margaret Crowe denied this, however, and stated that the bomber was definitely suffering from engine trouble. In this assertion, Gerry's wife was probably absolutely accurate. The RAF's training aeroplanes were often not of the greatest quality and were under-serviced, which certainly contributed to the fact that 15 per cent of Bomber Command's wartime air crew fatalities took place during training missions. The Albemarle bomber itself was of questionable reliability and seemed to experience particular problems with low-altitude turns. The Soviet Union signed a contract to receive hundreds of Albemarles from the British, but worries about performance and reliability were probably at the heart of their decision to drop the Albemarle order in favour of utilising more reliable American planes. In the RAF the Albemarle was used for transport functions, towing gliders into battle zones in Normandy, and subsequently at Arnhem, as part of Operation Market Garden. Gerry Crowe and his comrades may well have seen service at D-Day and Arnhem had they survived. Tragically, however, like many others in Bomber Command, they died while undergoing training. Sergeant Crowe now lies at rest in Hartford churchyard, in his home village. A plaque commemorating the service and sacrifice of V1609 was unveiled near the crash site in Hartford, in 2014.

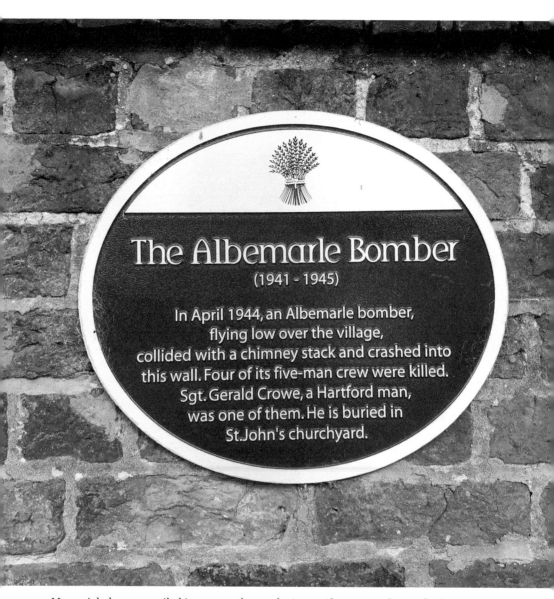

The Albemarle Bomber
(1941 - 1945)

In April 1944, an Albemarle bomber,
flying low over the village,
collided with a chimney stack and crashed into
this wall. Four of its five-man crew were killed.
Sgt. Gerald Crowe, a Hartford man,
was one of them. He is buried in
St.John's churchyard.

Memorial plaque unveiled in 2014 at the crash site on Chester Road, Hartford.

D

Delamere Forest

Delamere Forest was once a huge tract of woodland incorporating over fifty townships, stretching from the Welsh borders to the River Weaver, and the west side of the Castle area in Northwich. Its history stretches back to Norman times, when the then roughly 60 square miles of forest were the hunting preserves of successive earls of Chester, who maintained their rights to game, timber and other fruits of the woodland via often brutal enforcement of forest law. By the end of the eighteenth century much

Delamere Forest. (Courtesy of ReptOn1x)

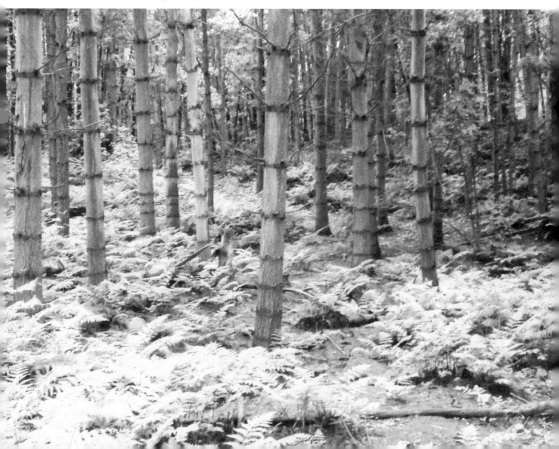

of the forest had been enclosed and cultivated, but much still remained. In 1924, the forest came under the control of the Forestry Commission. Roughly 2,400 acres of deciduous and evergreen woodland is still in existence, making it the largest forested area in the county. As a result, Delamere Forest remains an immensely popular recreational area, utilised by countless walkers, cyclists and horse riders. The forest is also an increasingly popular venue for outdoor concerts.

Edith Dempster and Sutton Hoo

Edith May Dempster was born in Yorkshire in 1883, and was the second daughter of Robert Dempster, a gas industrialist. At a very young age Edith's father, Robert, moved his factory to Manchester and settled with his family in Cuddington, Northwich. While in Cuddington the family went on world tours, travelling to Egypt, Greece, Austria-Hungary, British India and America. In 1907, her father acquired the lease on the Vale Royal Abbey estate, where Edith lived for most of the next two decades. During the First World War, Edith served as a quartermaster with the Red Cross Auxiliary Hospital in Winsford, assisted in the rehoming of Belgian refugees, and worked with the Red Cross on the Western Front in France. In 1919, her mother died and she spent a number of years caring for her ailing father at Vale Royal Abbey, until he finally died in Cape Town, South Africa, in 1925. He had left his two daughters an equal share of his estate, valued at £500,000 (the equivalent of roughly £16 million today). In 1926, Edith married Frank Pretty, who she had met during her wartime work with the Red Cross, when Frank had been serving with the Suffolk Regiment. After her marriage she chose to give up the lease on Vale Royal Abbey and moved with Frank to the Sutton Hoo estate in Suffolk where she became a local magistrate. At Sutton Hoo she made a

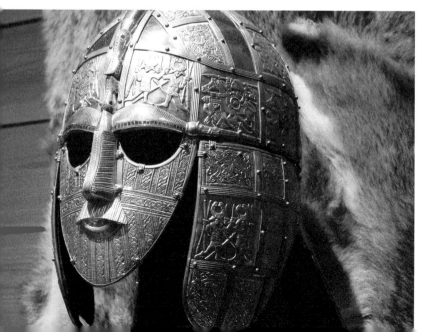

The Sutton Hoo Helmet. (Courtesy of Zico-C)

number of small archaeological finds, and in 1939 she paid Basil Brown, a self-taught archaeologist, to excavate her land. This was to prove extraordinarily fruitful, as Basil Brown went on to find a Saxon longboat, helmet and many other treasures in what became one of the most extraordinary archaeological discoveries of the twentieth century. It was certainly a discovery in which Edith Pretty, formerly of Vale Royal Abbey, played a pivotal role.

John Douglas – Architect

John Douglas was born in Sandiway, Northwich, in 1830 and rose to become an admired architect who influenced building styles in Northwich and throughout the North West. Douglas learned his trade in Lancaster, before returning to Cheshire in 1860 in order to set up his own architectural practice at No. 6 Abbey Square, Chester. Douglas learned how to design buildings in a Decorated Gothic style, influenced by Pugin and the Cambridge Camden Society. However, he was also inspired by Italian Gothic, Renaissance and other Continental European styles. R. E. Egerton-Warburton of Arley Hall was an early patron, as was the 1st Duke of Westminster. He also worked on many churches, including St Mary's Church in Whitegate, Northwich. Perhaps his most famous (and popular) works are the east side of St Werburgh Street and the Eastgate Clock in Chester. Douglas designed homes, churches and other buildings much further afield, however, and by the time of his death in 1911 he was a wealthy man – leaving an estate valued at over £32,000 along with the deeds to a number of properties. As the son of a Cheshire timber merchant, John Douglas had risen far, and his building designs were always highly individual with a recognisable style and character.

John Douglas, 1890.

English Civil War Battles and Skirmishes

The strategic importance of Northwich – very much an industrial town in a pre-industrial age – meant that both Parliamentarians and Royalists were keen to be in control of the area when fighting began in late 1642. For most of the Civil War period, Parliament was in control of the town of Northwich. Sir William Brereton, MP and deputy lieutenant of Cheshire, fortified Northwich on behalf of Parliament and organised the construction of defensive earthworks on Winnington Hill during 1642–43. The town also seems to have been the base for a locally raised regiment of Parliamentary foot soldiers, under Colonel John Leigh. Although there was little

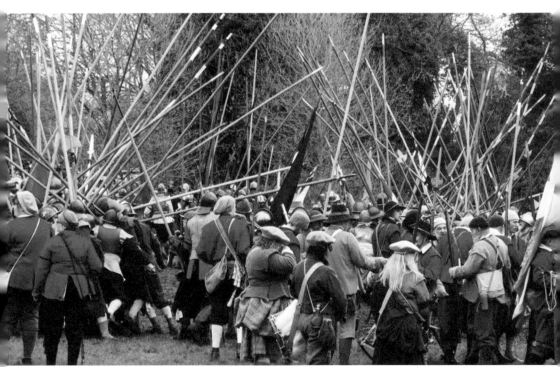

Re-enactment of an English Civil War battle in Cheshire.

large-scale fighting in Northwich, soldiers from the town did participate, on the side of Parliament, in the nearby Battle of Middlewich in March 1643 where they defeated a Royalist force under Sir Thomas Aston. Royalist troops were actually able to capture Northwich for a few short months at the end of 1643, but by spring the following year Brereton and his Parliamentary forces were back in control of the town. Northwich, however, was still threatened by Royalist forces. In May 1644, for example, Prince Rupert's Royalist army encamped at Rudheath for a few days while on the way to fight Parliamentary armies at York. This caused considerable alarm in Northwich and led the Parliamentary garrison to construct defences against Rupert's men at Witton. Later, in August 1644, Colonel John Marrow led Royalist cavalry in an attack on Parliament's positions at Northwich. Parliamentary forces advanced from Northwich to meet Marrow's cavalry, and a brief skirmish ensued at Sandiway. Marrow was killed in the fighting and the Royalists withdrew, although the overall level of casualties in the encounter is unknown. In 1649, Charles I was executed and the English Republic and Commonwealth was established. Fighting continued, however, between the supporters of Parliament and Charles Stuart (the future Charles II). Northwich was again briefly occupied by Royalist forces in 1651, as they marched southwards to try and reclaim the throne for the future Stuart king. The Royalist army that headed south out of Northwich was eventually defeated by Oliver Cromwell's New Model Army at the Battle of Worcester. The town of Northwich also became involved in Booth's Revolt of 1659, which was one of the very last armed encounters of the Civil War period. In 1659, Sir George Booth, a disgruntled Parliamentarian, led another attempt to topple the English Republic, which had been floundering since Oliver Cromwell's death in 1657.

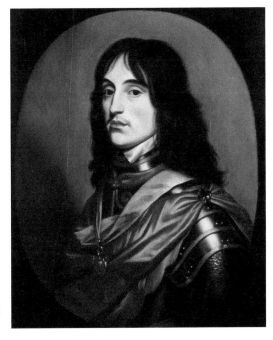

Prince Rupert of the Rhine by Gerard van Honthorst (1630–56).

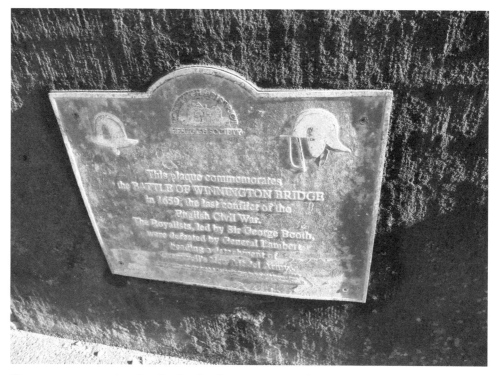

Plaque commemorating the 1659 Battle of Winnington Bridge. (Courtesy of ReptOn1x)

Booth and his Royalist troops (based in Chester) successfully took over Northwich. In response, Parliament sent the experienced former major-general, John Lambert, who was once seen as the probable successor to Oliver Cromwell, to crush the revolt. On 19 August 1659, Lambert's men clashed with Booth in a running battle that began at Hartford and ended at Winnington Bridge. Booth's men were routed entirely, and Booth was subsequently captured and imprisoned in the Tower of London. Lambert might have been the victor at Winnington Bridge, but it was Booth who turned out to be ultimately triumphant. Charles Stuart was restored to the throne, as Charles II, in 1660, and Booth was released from prison. Lambert, however, as a former close friend of Oliver Cromwell and a key New Model Army general, was shown little mercy by Charles II's new regime. Though he was spared execution, the victor of Winnington Bridge spent the rest of his life in prison, before finally dying in 1683.

Express Message System

The chief constable of Cheshire between 1934 and 1935 was Captain A. F. Horden. Horden's appointment as the county's chief constable had been somewhat controversial and questions were asked in parliament about whether his previous connections and experience made him suitable for the job. Government officials were

able to respond by pointing out that Horden had been a spy during the First World War, working for MI5, and was experienced in dealing with both Special Branch and other parts of the police service. Horden stayed on as Cheshire's chief constable and subsequently had a distinguished police career. One of his chief claims to fame in this period was the fact that he was largely responsible for instituting the first version of a national police messaging service, which could be used to catch criminals and solve crimes. This service quickly became known as the Express Message System. Ironically, the new system was used almost immediately to solve a crime within Horden's own 'patch' of Cheshire. During one evening in 1935, a bookmaker returned to his home in Northwich to find that his safe (containing the considerable sum of £7,500 in banknotes and £150 in silver and copper coinage) had been stolen. He immediately reported the crime at Northwich police station, and Horden's new Express Message System (EMS) quickly swung into action. Details of the banknote numbers and denominations were gathered and then sent to 147 different police headquarters, and London and Manchester newspapers, using EMS. The publicity generated by the use of Horden's new system clearly worked because the safe was found in Denbighshire six days later, and an informer tipped off police that one of the robbers was a man named William Parkinson. Parkinson was subsequently arrested, as were further members of the Northwich safe robbery gang, and all but £200 of the money originally stolen was finally recovered. The new EMS, tested so speedily in Northwich, was clearly a great success.

Captain A. F. Horden, chief constable of Cheshire. (© Cheshire Constabulary)

Ethel Frater (née Barrow)

Ethel Barrow was born in Old Lane, Lostock Gralam, in 1904. Her father, William Barrow, owned and ran a transport and removals business in Lostock, but sadly died from pneumonia one week after Ethel was born. Her mother, Martha, supported the suffragettes and continued to run the business on her own, as well as bringing up Ethel and her three siblings. By 1911, Martha was also acting as a coal merchant, in addition to running the family removals business. The family had a team of Clydesdale horses to assist them in the business, and young Ethel would sometimes ride them, bareback, to be reshod at the local blacksmiths. Ethel attended Sir John Deane's Grammar School where she proved to be a very able scholar. She went to Liverpool University in the early 1920s and studied medicine. She graduated second in her class in 1925, and was registered with the General Medical Council in 1926. She found it difficult to secure an appropriate medical post in England, as most internships for new doctors had been reserved for war veterans. As a result, Ethel moved to San Francisco, where she secured an internship at a women and children's hospital. In her first year as an intern in San Francisco, Ethel contracted diphtheria from a patient and nearly died. Despite illness and a heavy workload, young Ethel still had time for non-medical pursuits. In her spare time, the energetic new intern would hitch-hike to Mexico and back with her friend Miriam Roskin. For her second year as an intern, Ethel Barrow joined the famous Mayo Clinic in Minnesota, where she specialised in pathology and bacteriology. Here, she met and then married a South African doctor called Kenneth Frater, and moved to South Africa with him in 1928. Over the next four decades, Ethel Frater campaigned for better birth control for the poor in South Africa. She also campaigned for female doctors to be paid the same as men and for non-white nurses to be trained and paid the same as white nurses – all this was done while the country was in the strong grip of an authoritarian apartheid regime. Ethel also taught microbiology at the University of Cape Town Medical School and was director of the city's St Monica's Hospital for Women, where she developed the country's first advanced training school for non-white midwives. After a glittering medical career spanning two continents, Ethel Frater retired to England in 1969, where she joined the selection board for Voluntary Service Overseas

F

Ethel Barrow's (née Frater) legacy as promoted by the E. Barrow Medical Group, Dallas, Texas. (© Dirk Frater)

and wrote a history of the tea trade for the Linnean Society (for which she became an honorary member). She lived in London and, after surviving a broken hip at the age of eighty-nine, continued to travel by bus until well into her nineties. Ethel visited South Africa for one last time at the age of 100, when midwives and gynaecologists travelled from all over the African subcontinent to meet the pioneering centenarian doctor and activist. Although Ethel Frater died in 2007, at the grand old age of 102, her medical legacy lives on in the USA. In 2008, one of her grandsons set up the E. Barrow Medical Practice in Dallas, Texas, which is dedicated to the memory of the talented doctor from Lostock Gralam, Northwich.

Gibson, Fawcett and Polyethylene

During 1933, at ICI's Wallerscote Island research laboratories in Northwich, Reginald Gibson and his colleague Eric Fawcett were experimenting with gases at high temperatures. One of their experiments went slightly awry, with Gibson commenting in his simple notes of the time: 'waxy solid found in reaction tube'. In fact, they had discovered polyethylene, or polythene as it is better known today. The German scientist Hans von Pechmann had found much the same substance in a similar experiment in 1899, but had failed to appreciate its significance. Thus, it is Gibson and Fawcett, in Northwich, who are officially accredited with discovering the new material. The process of developing commercially viable polythene proved to be a long and rather tortuous one, and it wasn't until 1939 that the material began to be produced on an industrial scale. During the Second World War, polythene played a vital role in the insulation of radar cables. Since then, the material has been used for virtually everything, from pipes to food packaging, but the environmental cost of its use has been enormous.

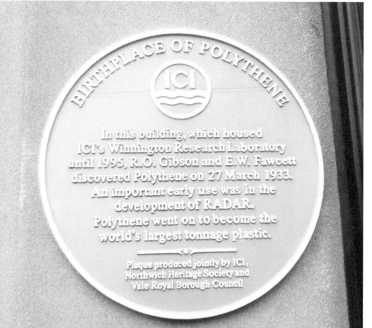

Plaque unveiled in 2006 commemorating the discovery of polythene in 1933.

Great Budworth

The parish of Great Budworth, which lies just 2 miles to the north of Northwich, is one of the most picturesque locations in Cheshire. The history of the village goes back at least 900 years to the time of William the Conqueror and the writing of the Domesday Book. For many hundreds of years, Great Budworth was controlled by the owners of Arley Hall. In fact, the village was part of the Arley Hall estate right up until 1948. The Lord of Arley, prior to 1948, would collect rents from all the villagers in payment for the lands, dwellings and other facilities they utilised on Arley lands. The chocolate-box image of the modern village (much loved by location-finders for various recent film and TV projects) owes much to the efforts of Rowland Egerton-Warburton, owner of Arley Hall in the mid-nineteenth century. Rowland used the money he received from the villagers' rents to remodel and develop Great Budworth, so that it appealed more to Victorian tastes and aesthetics. As part of this process he commissioned prolific architects, such as Chester's John Douglas as well as William Nesfield, to work on various buildings in the parish. In addition, Egerton-Warburton also paid for restorations and improvements to be made to the historic Great Budworth village church of St Mary and All Saints. John Douglas's influence is significant throughout Great Budworth. Dene Cottages were completed by Douglas, for Egerton-Warburton, between 1867 and 1868. After this, Goldmine House and the attached Rose Cottage were also built by Douglas, in 1870. Douglas also developed his design skills by restoring the George and Dragon public house in Great Budworth in 1875. The location remains a popular public house and restaurant with both locals and visitors to this day. Four dwellings, between Nos 54 and 57 High Street, which had originally been built in the early eighteenth century, were also restored

St Mary and All Saints Church, Great Budworth. (Courtesy of JooperCoopers)

by Douglas for the Arley Hall owner. Though John Douglas designs clearly dominate Great Budworth, other architects and designers also made an impact. A mile outside the centre of the village lies the impressive Georgian Belmont Hall, a country house designed by James Gibbs in 1755 for the Smith-Barry family. Between 1919 and 1926, the hall was a major centre of social and business activity. It was the home of Roscoe Brunner, chairman of Brunner Mond, and his wife, Ethel. Roscoe used the hall as a working office and held key meetings there, while Ethel hosted at least one grand Conservative Association gathering at the hall, attended by over a thousand people. Since 1977, this magnificent Grade I listed building has been the home of Cransley School, an independent girls' school, which became co-educational in 2014.

Left: Great Budworth High Street. (Courtesy of Mike Peel)

Below: Belmont Hall.

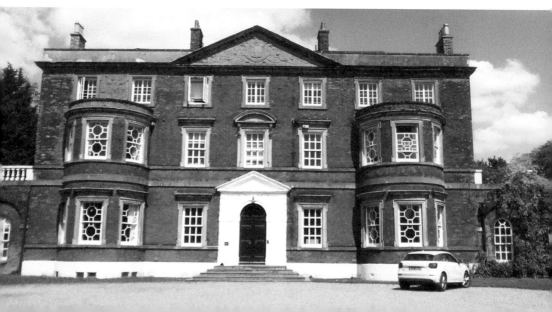

H

Hosken-Harper Memorial

The mid-nineteenth-century memorial fountain dedicated to the memory of John Hosken-Harper, which is situated at the junction of London Road and Fountain Lane in Davenham, represents a little-known link between Northwich and the dark days of the slave trade in the late eighteenth and early nineteenth centuries. William Harper was a major Liverpool slave trader. He purchased Davenham Hall from trustees of the estate of Thomas Ravenscroft, who had died in 1795. Between 1784 and 1799, Harper made fifty-two voyages to various parts of the world, buying and selling slaves, and he clearly made a great deal of money from his involvement in the slave trade – he left an estate worth £7,000 at the time of his death in 1815. William Harper's daughter, Ann, married a Cornishman called John Hosken, who inherited Davenham Hall as a result of Harper's will, provided that he added the name Harper to his own surname. It is this John Hosken-Harper who is remembered in the Grade II listed memorial on Fountain Lane. John Hosken-Harper also owned slaves himself, probably inherited from his father-in-law. Rather incredibly, as a result of a legal claim settled in 1836, Hosken-Harper received over £714 in compensation for the 'loss' of forty-two slaves he had formerly owned in the Caribbean colony of Montserrat. Presumably, the 'loss' had occurred when the slaves were given their freedom as a result of the 1833 Act of Parliament that banned slavery throughout the British colonies. The Northwich Hosken-Harpers were not alone in being compensated for losing their income as slave owners. Across the country, 3,000 British Victorian families were paid a total of £20 million in compensation for being deprived of their slave-owning income. No such compensation was offered to give the slaves themselves a fresh start in life. During the early 1820s, John Hosken-Harper and his wife ploughed much of the money they'd inherited from William Harper's slave trade profits into a redevelopment of the Davenham Hall property. They transformed the hall into the impressive building that we can see today. By the time of his death in 1865, John Hosken-Harper had been a magistrate and a deputy lieutenant of Cheshire for many years. His son, William, inherited Davenham Hall and was probably instrumental in ensuring the construction of the memorial to his father at Fountain Lane. Whether or not he knew the full dark secrets of his family's involvement in the slave trade, however, is perhaps open to question.

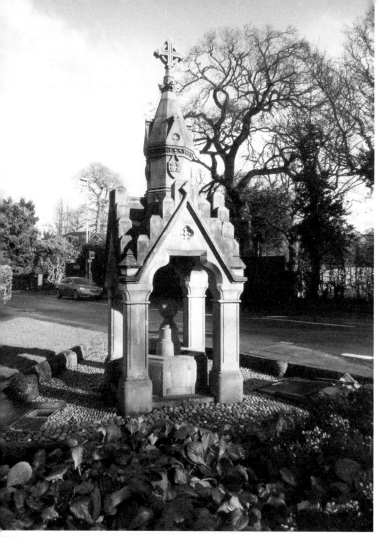

Left: The Hosken-Harper Memorial.

Below: Davenham Hall. (Courtesy of Mike 17047)

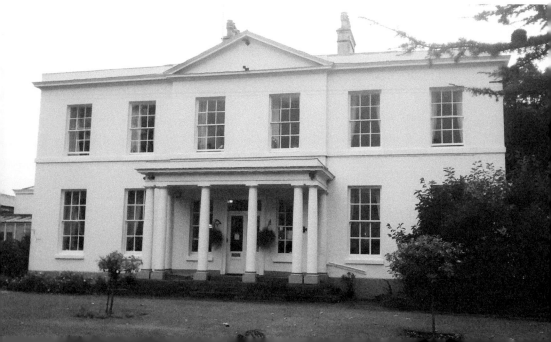

Charles Hughes

Charles James Hughes was born in Applegate Street, Northwich, on 16 August 1853 and grew up to become one of the great sporting figures of Victorian Cheshire. He was a notable figure in the development of both rowing and cricket in Northwich. He also indulged in athletics and became a figure of national importance in the development of Association football. Yet, Charles Hughes was much more than just a sportsman. His 1901 census returns show that he was an auctioneer and valuer, setting up his own auction house business under the name of Charles Hughes & Son. He also became a Justice of the Peace, an honourable auditor of the Victoria Hospital on Winnington Hill, a Conservative political agent during four Northwich parliamentary elections, and a governor of Witton Grammar School. However, it is for Charles Hughes' role in developing the game of Association football that he chiefly deserves to be remembered. He was a co-founder of Northwich Victoria FC in 1874 and played in the team's first recorded game against Stedman College in that same year. Sadly, his playing career came to a premature end in 1877 when he broke his ankle in a game against Hanley Rangers at the Drill Field, Northwich. It was at this point that Hughes made the transition from being a player to being a football administrator and official. Crucially, he did this at a key time in the evolution of Association football, when proper rules were being formulated for the game and when leagues were being established. The ex-Northwich Victoria player became a co-founder of the Cheshire Football Association in 1878, and he stayed on as the honourable secretary of the association for the next thirty years. In addition, Hughes acted as the vice president of the national Football Association in 1901. Charles also became a football linesman and referee of some distinction. In the 1890s, he refereed a number of the early English FA Cup finals, and in 1892 the Northwich man was a linesman at Ibrox Park, Glasgow, during one of the early England v Scotland Home International fixtures. England won the game 4-1, in an encounter watched by 20,000 people. Rather unusually, though, Hughes combined his linesman role with being a member of the seven-man FA International Selection Committee, which picked the England team for the match. It would be virtually impossible to envisage such an event occurring in modern times, but things were clearly very different in the Victorian amateur game. In the early years of the twentieth century, the England football team wasn't picked by an all-powerful manager who was solely responsible for selection decisions. Instead, the selection procedure was similar to the practices followed in English rugby union and cricket, where a group of selectors, headed by a chief selector, chose the team. By 1907, Charles Hughes was the selector in charge of the English football team, both at home and abroad (when the team was on tour). In 1907, the team largely – but not completely – selected by Hughes drew 1-1 against Wales, in a game played at Craven Cottage, Fulham, in front of 22,000 people. As the selector in charge of the side Hughes had, in many respects, reached the pinnacle of the football game in England at that time. Hughes died nine years later, in 1916, though the significance of his death

Charles Hughes,
Northwich football
pioneer.

was largely overshadowed by the gloom and terrible casualties of the First World War. Nevertheless, the Northwich auctioneer and father of six had achieved much during his lifetime. As a player, linesman, referee, senior Football Association official and chief selector of the England football team, Charles Hughes did more than most to develop and enhance a game that dominates the modern sporting world.

I

ICI (Imperial Chemical Industries)

In 1926, Brunner Mond of Winnington merged with three other chemical companies to create the massive new international Imperial Chemical Industries conglomerate (ICI). Alfred Mond, the son of Ludwig Mond, was one of the key figures in bringing about this merger. The Brunner Mond business became part of ICI's Alkali Division and continued to be one of the largest and most successful companies in the world for many years after the end of the Second World War. ICI eventually sold off the Brunner Mond part of their empire to Tata Chemicals (a massive Indian-owned conglomerate) in 2006. ICI itself became part of the Dutch Akzo company in 2008, though the original Brunner Mond chemical plant in Winnington continued to run, at a much-reduced capacity, until 2018. A small, residual production capability has been maintained at nearby Lostock Gralam.

Winnington ICI plant. (Courtesy of Dave P. Howarth)

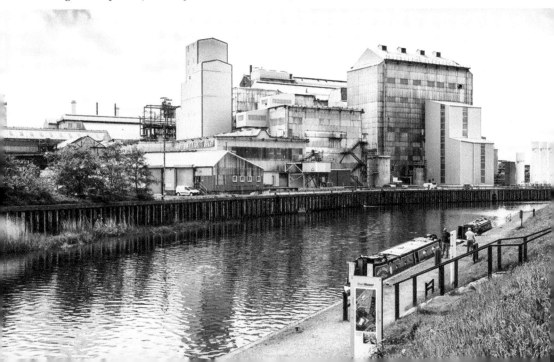

ICI and the Rose Cottage Murder Mystery

On the evening of 3 November 1926, Harold Roscoe Brunner, son of Sir John Tomlinson Brunner, shot his wife dead at close range in their daughter Shelagh's cottage, then turned the gun on himself. The tragic and mysterious deaths of the two people made headline news across the world. What had caused it? Why had the prominent Northwich-born industrialist, a deputy lord-lieutenant of Cheshire and JP, apparently committed murder and then shot himself while staying at Rose Cottage, Roehampton? The puzzling events caused some fevered speculation to arise, and at the inquest the coroner condemned the press wholeheartedly for some of their comments. It seems likely, from what Roscoe's elder brother, Sir John Fowler Brunner, said at the inquest, that the pressures of business played a key role in the events. Roscoe had been the chairman of the Brunner Mond chemical giant until a legal dispute about a Lever Brothers commercial contract had forced him to step down from the position. Roscoe's fall from grace happened at exactly the same time as a huge merger was being planned, which would bring Brunner Mond and other companies together to form the vast Imperial Chemical Industries conglomerate. To the undoubted dismay of Roscoe and his wife, Ethel, Roscoe failed to be offered any position on the board of the new ICI. Instead, Alfred Mond, son of Ludwig Mond (the other great co-founder of Brunner Mond) became chairman of ICI. Roscoe's business pride definitely seems to have been hurt by the snub. Ethel's anger was also obvious and she seems to have given public vent to her fury at Roscoe's exclusion, in front of newspaper journalists and influential friends, on a number of occasions. His wife's actions would have dismayed and embarrassed Roscoe very much, according to the inquest testimony of his elder brother. It was this combination of business pressures and private humiliations,

Harold Roscoe Brunner (1871–1926). (© Catalyst Widnes)

which, according to the coroner and jury, led Roscoe to commit murder and suicide. Whether or not this is entirely true is open to question. Many of the files on the case remained secret, while others have been conveniently lost. As a result, conspiracy theorists have had plenty of room to argue that big business interests, and politics, also played a significant role in the mysterious goings-on at Rose Cottage.

Italian Tragedy

Little is known about J. T. Brunner's second son, Sydney Herbert Brunner, born in 1867. In 1885, he was part of the grand procession that celebrated the opening of the Northwich Free Library when he rode in the same carriage as his elder brother, John Fowler Brunner, and his uncle Henry. Other than this, little was recorded about the life of the young man. Like his brothers, Sydney was educated at Cheltenham College. He then went on to Pembroke College, Cambridge, where he graduated with a BA degree before pursuing further studies in engineering at Edinburgh University between October 1889 and June 1890. Sydney's elder brother, J. F. L. Brunner, studied as an undergraduate at Trinity College, Cambridge, at exactly the same time as his brother was based at Pembroke. At some point both brothers decided to join a family holiday that summer to Lake Como in northern Italy. At the lake, on 8 September 1890, Sydney died in a tragic drowning incident, while trying to save the life of his older brother. Presumably one or both men had been swimming, and the elder brother got into difficulties. Sydney died in the act of saving his brother. His body was recovered two days later, on 10 September, and he was buried in a grave beside Lake Como the following day. The brief, if poignant, epitaph on Sydney's pale Lake Como gravestone, which can still be seen today, reads: 'A white flower for a blameless life.' The elder brother that Sydney saved went on to succeed to his father's baronetcy and become Northwich's MP. He also became (unlike Harold Roscoe Brunner) a director of ICI during 1926–27.

Lake Como, Italy,
c. 1890.

Jarmays of Hartford Lodge

Gustav Jarmay and his wife Charlotte played a distinguished role in Northwich (and national) life during the early part of the twentieth century. Gustav was born in Budapest, Hungary, in 1856 and came to the UK in 1875 in order to make a new life for himself. He was already a highly trained chemist by the time he came to England, having earned a chemistry degree from the Zurich Federal Polytechnic. After a short time working at Greenhall Whitley's in Warrington, Ludwig Mond invited Jarmay to assist him with some of the more routine analytical research tasks at the new Brunner Mond Winnington Hill plant in Northwich. By the early 1880s, Gustav Jarmay was the technical manager of the plant, and by the end of 1890 he was a board member and one of the key directors of the whole Brunner Mond company.

Gustav Jarmay (back row, fourth from right) with Brunner Mond's Board of Directors in 1913. (© Catalyst, Widnes)

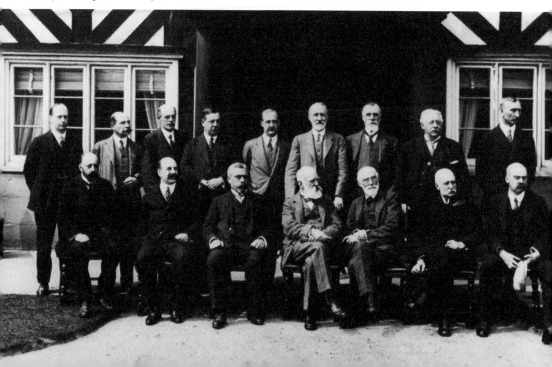

Jarmay's rise to power and wealth at Brunner Mond had been meteoric, and by the early 1900s he was living in some opulence at the substantial Hartford Lodge (now called Whitehall) in School Lane, Hartford. He was living the life of an English country gentleman, and by 1906 he was the owner of a racehorse called Prince George and a member of the Cheshire Hunt. In 1912, he also purchased one year's sporting rights on a stretch of land by the River Dee for the not inconsiderable sum of £500. During the First World War, Jarmay's star rose much further. He played a crucial role in improving the quality of British high explosives, and Lloyd George's Minister of War, Lord Moulton, was instrumental in securing a knighthood for the Brunner Mond director as a reward for his services to the British war effort. At the end of the war, Gustav Jarmay retired from Brunner Mond and lived in Italy for a time. By the time of his death, in Hertfordshire, in 1944, he was seen by many to have been a major figure in the development of the British soda ash industry, on a par with both Brunner and Mond, though in more modern times his contribution to the success of the Brunner Mond empire has received rather less attention. Gustav married Charlotte Wyman, the daughter of a Northamptonshire doctor, in 1881. This in itself must have helped Gustav's rise to the top of his profession, because Charlotte was the cousin of Sir John Brunner's second wife, Jane Wyman. The relationship between Jane and Charlotte must have been a close one – more like sisters than cousins – because Jane was actually brought up by Charlotte's father, George Wyman. Charlotte herself played a notable role during the First World War. She became a VAD

Hartford Lodge (now called Whitehall) – once the home of the Jarmays.

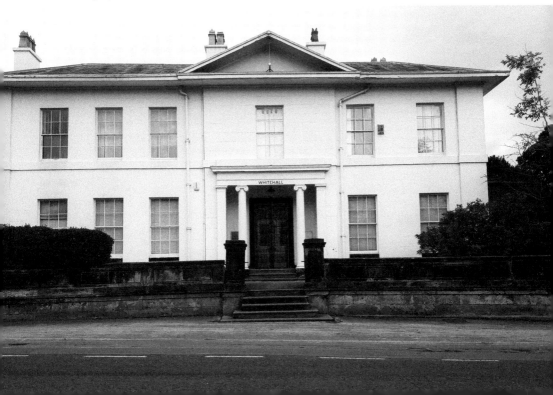

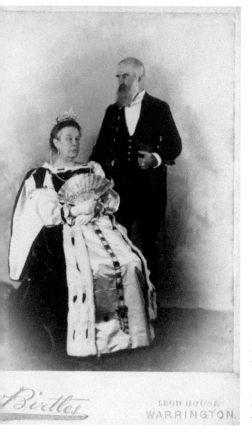

Birtles
LEON HOUSE
WARRINGTON.

Left: Lady Jane Brunner (née Wyman) in a rather regal pose with her husband. (© Catalyst, Widnes)

Below: Hartford Hall, now a bar and hotel, but once the home of the Hatt Cooke's First World War hospital Working Party.

HARTFORD HALL

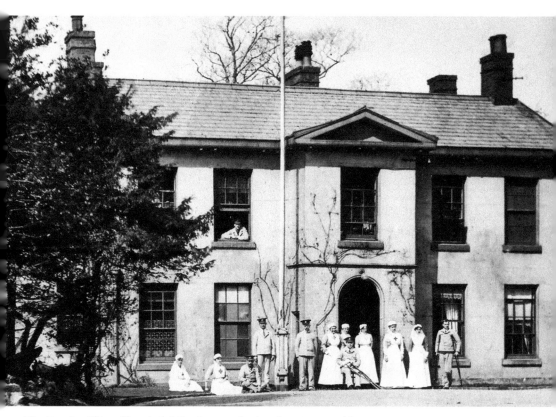

The Ley Auxilliary Hospital, Winnington, during the First World War.

(Voluntary Aid Detachment) nurse, but more importantly she registered her home at Hartford Lodge as the base for a hospital Working Party, staffed by volunteers, during the course of the war. The Hartford Lodge Working Party was one of a number set up in Hartford and throughout Northwich, where volunteers made bandages, splints, blankets and hospital clothing for the local auxiliary hospitals catering for wounded soldiers. The great and the good of the area, including members of the Brunner family at The Hollies in Hartford, the Hatt Cook's at Hartford Hall, and the Dempsters of Vale Royal Abbey, all registered their houses as Working Party bases. Charlotte Jarmay, however, did much more than this. She also created a Working Depot at Hartford Lodge, where all the hospital clothing and provisions made by the local Working Parties could be gathered together and then forwarded onto local auxiliary hospitals. Even this wasn't enough for the energetic, middle-aged Charlotte Jarmay because she also became the co-commandant of the Ley Auxiliary Hospital, based on Brunner Mond property at Winnington. As the commandant of an auxiliary hospital, Charlotte would have been in control of all aspects of the hospital, except for the actual provision of medical and nursing services to the recovering soldiers. The wife of one of Brunner Mond's principal directors had given herself a prodigious wartime workload, and in 1919 her efforts were recognised by the award of an OBE.

Jubilee Street and the 1946 Floods

The centre of Northwich, being at the confluence of two major rivers, has been subject to major flooding for hundreds of years. Central Northwich was, for example, inundated by floodwaters in 1872, 1914 and 1920. Perhaps the most catastrophic flooding occurred after fourteen consecutive days of rain, in February 1946. The banks of the River Weaver and the River Dane burst on 8 February, leaving much of the centre of the town inundated by up to 7 ft of floodwaters. The damage caused was immense, leading one local councillor to declare that the floods were the biggest disaster the town had ever faced. The long-since demolished road of Victorian terrace houses on Jubilee Street, near the Hayhurst Bridge, were at the very centre of the floods. Decades later, residents of Jubilee Street reminisced to local journalists about how their families had been forced to flee upstairs to escape the rising floodwaters, and hang white towels from their windows in order to show that they were in need of rescue. Residents from nearby Queen Street (still in existence) and elsewhere were also rescued and transported by army vehicles to temporary accommodation

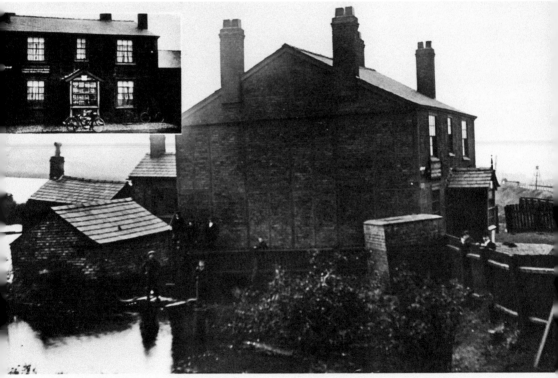

SHOWING OUTBUILDINGS PARTLY SUBMERGED BY WATER CAUSED THROUGH DANGEROUS SUBSIDEN
AT "TOWNSHEND ARMS". WITTON BROW, NORTHWICH. 1913.

The Townsend Arms, Northwich, flooded as a result of subsidence in 1913. (© Weaver Hall Museum)

at the baths hall on Victoria Road. The Regal Cinema, on Dane Street, was also hit hard, and all film showings were cancelled as the water began to lap at the cinema's steps. Later on, floodwater submerged all the cinema's seats, marooning the manager (and some staff) in his office for at least a day. Other Northwich residents began to flee, en masse, to the higher ground of Castle Hill and Verdin Park. The disaster of 1946 has never quite been repeated, though there was further flooding in 1977, 2000 and 2012. Post-war flooding, but particularly the events of 2000 and 2012, led to over £7 million being spent on flood defences in an Environment Agency scheme, completed in 2017. There are now 1.7 km of new flood walls and embankments in position along the banks of the Weaver and the Dane, designed to reduce the risk of further severe flooding.

Edward Knowles and the *Northfleet* Disaster

The Knowles family were well known in Hartford, Northwich, during the last decades of the nineteenth century. Edward Knowles Snr and his wife ran the school (on School Lane, Hartford) where the local Hartford children received their basic education for well over twenty years, from the 1860s onwards. However, it was their son, Edward Jr who rose to national and international attention as a result of the sinking of the *Northfleet* sailing ship, off the coast of Dungeness, on 22 January 1873. The ship was sunk by a Spanish steamer called the *Murillo* in a terrible accident that represented

The Old School House, Hartford.

one of the worst maritime disasters of the Victorian era. Edward bravely went down with his ship along with over 280 men, women and children bound for new lives in Australia. Knowles' wife, who was also on board, was one of only two women to survive the sinking. The story was reported all around the world and Queen Victoria was so moved by the incident that she decided to pay Edward Knowles' widow a pension out of her own pocket.

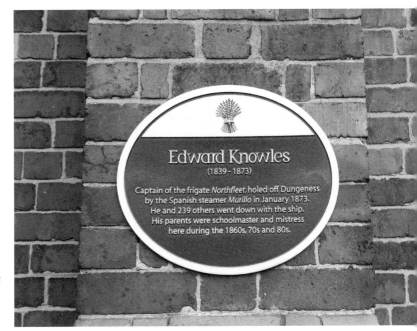

Right: Old School House plaque commemorating Edward Knowles and the 1873 *Northfleet* disaster.

Below: The *Northfleet* on the Thames a few days before her loss in 1873.

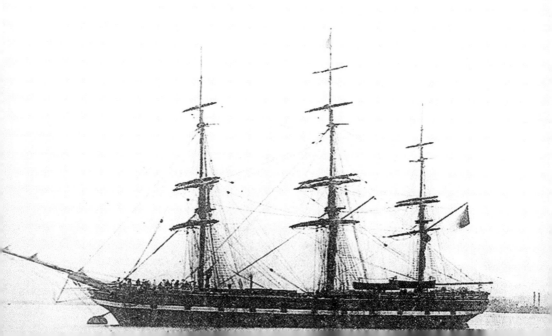

Landmarks

The recessed spire of St Wilfrid's parish church, Davenham, which is 99 feet long (from parapet to the top of the spire) is a significant local landmark, visible for miles around and a very familiar sight to drivers on the A566 bypass road, just south of Northwich. The church itself has a very long history stretching back to the eleventh century, when there was certainly a church on the site at the time of the Domesday Book in 1086. A revised church was constructed in the fourteenth century, with new chancels added in 1680 and then at the end of the eighteenth century. The church as it

St Wilfrid's Parish Church, Davenham.

stands today was really developed in the early Victorian era, between 1842 and 1844, when Edmund Sharpe from Lancaster (with E. G. Paley) demolished much of the previous building, with the exception of the tower and steeple, and constructed a new and larger place of worship. The church is a Grade II listed building, with numerous points of interest. For example, the renowned Scottish architect Sir Robert Lorimer designed both the war memorial chapel and the 1927 Arts and Craft style tomb for the Allen family, which is found in the eastern part of the graveyard.

Lion Salt Works

The Lion Salt Works is the last remaining open-pan salt works and is situated in Marston, Northwich. Production actually ceased in 1986 and the works is now preserved as a museum. The salt works was started by John Thompson in 1894, when he sunk a salt pan in the coal yard of the Red Lion Hotel, Marston. The Thompsons were really a salt dynasty, with over six generations of the family running various salt-related businesses in the Northwich area between 1799 and the closure of the salt works in 1986. Thompson salt was dispatched all over the world and proved to be particularly popular in the countries of West Africa, where it withstood the high temperatures and humidity of the tropics.

The Lion Salt Works. (Courtesy of Roger Kidd)

Ludwig Mond

Mond was a German chemist, born in 1839, who adopted British nationality in 1880. He was living and working in Cheshire by the early 1860s, but his association with Northwich begins in 1873 when he formed a business partnership with John Brunner and began to construct a chemical plant at Winnington. By 1880 the Northwich plant was running as a commercially viable business, and by the end of the century Brunner Mond was the largest producer of soda in the world. While he was establishing his business he lived in Northwich at Winnington Hall with his wife, Frida, and their two sons, Robert and Alfred. However, as his wealth and fame spread, Mond moved to a substantial home near Regent's Park, London, in 1884. He also acquired a home called the Palazzo Zuccari in Rome, where he spent most winters. When Ludwig Mond finally died in 1909, aged seventy, he left an estate valued at just over £1 million – an astronomical sum for the Edwardian era.

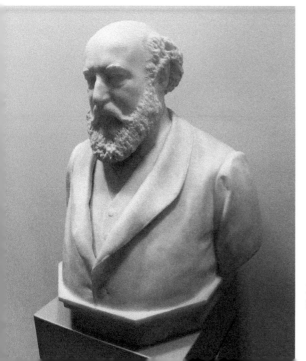

Bust of Ludwig Mond, Royal Institution. (Courtesy of Vera de Kok)

Marbury Country Park. (Courtesy of Tigershrike)

Marbury Hall and Park

Various houses have existed on the site near Comberbach, Northwich, since the thirteenth century. These houses formed the seats of the Marbury, Barry and Smith-Barry families right up to the early 1930s when Marbury Hall became an exclusive country club. The final version of the house was remodelled and extended in 1856. It had aspects of both French and Queen Anne styles about it, but was finally demolished in 1968. Although the house no longer exists, the parkland and gardens of the Marbury estate still remain and are popular with visitors throughout the year.

Marks and the Salty Dog

The Salty Dog public house is currently located at Nos 21–23 High Street, Northwich. It has one of the most interesting and best-kept exteriors of the traditional black-and-white buildings in central Northwich. Look upwards and your eye is easily taken by the three carved monsters on view. At both ends of the building's frontage are two colourful and well-preserved figures representing a nightwatchman and the town crier. In between these two figures, a man and woman are both depicted carrying mugs and plates – these figures are often referred to as the mayor and his wife. These carved figures, so distinctive today, were equally distinctive nearly ninety years ago, when staff from Marks & Spencer were photographed underneath the same carvings. The building, now occupied by the Salty Dog, has quite a long history, stretching back to at least 1908, when Marks & Spencer opened its first Penny Bazaar branch in what is now the central part of the Salty Dog. Marks & Spencer stayed at this location until 1933,

when the branch moved further up Witton Street to the premises currently occupied by Clintons. Marks & Spencer stayed at this location for nearly sixty years, extending the store to the rear, encompassing space subsequently occupied by Greenwood's, the tailors, and Adams. In 1992, Marks & Spencer moved to its current location on Leicester Street when it took over the building formerly occupied by Sainsbury's.

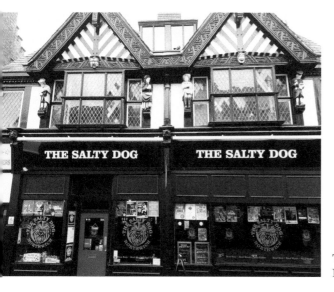

The Salty Dog, Nos 21–23 High Street, Northwich.

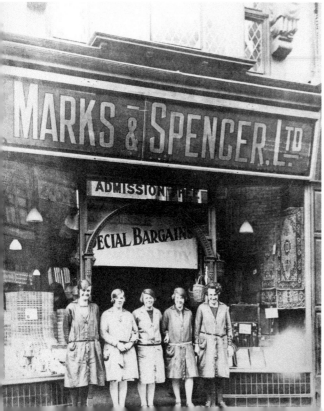

Marks & Spencer, No. 21 High Street, Northwich, *c.* 1930.

Northwich Public Library

The library that can currently be seen on Witton Street is the second library to be based at roughly the same location in central Northwich. The first library, which opened to considerable fanfare on 21 July 1885, was financed by J. T. Brunner and built on the site of the former Northwich Workingmen's Club (also owned by Brunner). It had a 30-ft-high glass and wood domed entrance hall dominated by Jabez Thompson's terracotta works. Four years later, the building also became the home of the Northwich Salt Museum. During the 1890s, the building was repeatedly damaged by the effects of subsidence, and in 1907 the decision was taken to demolish the entire structure. A new and bigger library, again financed by J. T. Brunner, was built in 1909. The new library, designed by A. E. Powles, was built in the classic black and white Tudor style via the composite timber-frame method, which ensured that in the event of future subsidence the building could be lifted and moved to another location.

Northwich public library, built in 1909.

Oakmere

Oakmere is a small village just to the east of Northwich, which is of a mainly agricultural nature, though it does possess a number of sand quarries. The village had a population of 252 in 1851, which had risen to just 589 by 2011. Prior to 1873, the village held court sessions in a room linked to the Abbey Arms Inn (a public house that

Oakmere Lake. (Courtesy of David Carney)

still exists today, with the addition of a restaurant). After this date minor miscreants could be judged in the new Oakmere courthouse, which had the convenient additional facility of three new prison cells. The village takes its name from the nearby Oak mere or lake, which is a large body of water formed in the fluvio-glacial sands of the Cheshire Plain. The Oakmere Lake site supports a number of plants that are now rare in the English lowlands, such as floating bog moss and narrow small reed. In order to protect the rare flora and fauna on site, Oakmere Lake has been declared a Special Area of Conservation. As a result, the whole area is very popular with natural history enthusiasts. Visitors to the area can now also walk along the new Oakmere Way footpath and bridleway, which links Oakmere with Delamere Forest and the Sandstone Trail.

Oakmere Hall

Oakmere Hall, Northwich, was a John Douglas-designed house built in 1867 and situated to the south of the parishes of Cuddington and Sandiway. The building was one of Douglas's earliest and largest house designs. It was occupied by a series of wealthy merchant owners between 1867 and 1943, when it became a rehabilitation centre for injured miners. In 1951, it became part of the National Health Service and was used as part of the rehabilitation process for all kinds of different people. The hall has now been converted into flats and apartments for private use.

Oakmere Hall. (Courtesy of Peter I. Vardy)

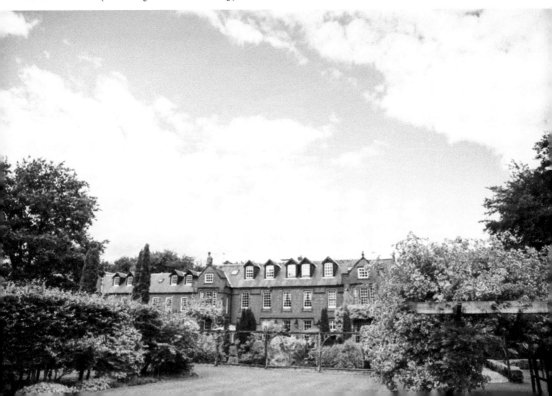

Parr's Bank

The building on Dane Street in which Parr's Bank once operated is still visible today, having been impressively restored by a private insurance broker in the 1980s. During this period, a considerable renovation of the whole site was undertaken. The building was lifted 4 ft using the traditional lifting methods of jacks, pulleys and manifolds employed by earlier generations of local engineers. As such, this was the last building in Northwich to be lifted in the traditional way. However, this wasn't the only time

Side view of Parr's Bank building from across the River Dane.

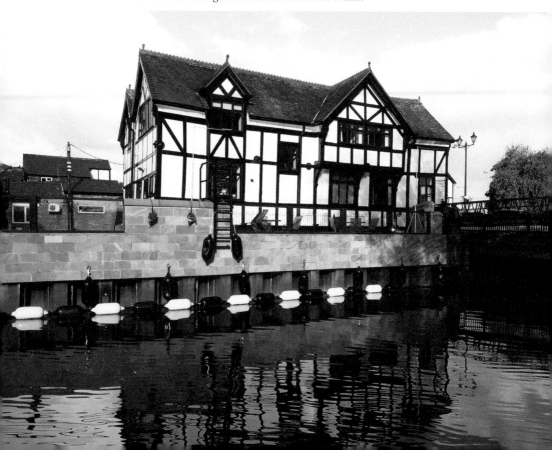

Victorian glass skylight from Parr's Bank building, *c.* 1880s.

that the Parr's Bank building had been raised and repositioned. Way back in 1921, the whole Parr's Bank building had been raised by 7 ft and then lowered again onto a brick pier, in order to escape the dangers of subsidence. The bank continued with its business throughout the whole complex procedure, apparently without interruption, and without any damage being caused. Originally, Parr's Bank was a private bank, established in nearby Warrington in 1788 (it was also known as Warrington Bank). The bank expanded steadily over the following years, and in 1865 it became a limited liability concern trading under the name of Parr's Banking Co. Ltd. In the same year, Parr's Bank expanded its activities into Northwich, when it acquired the banking business formerly known as Thomas Firth & Sons. During the 1870s, Parr's advanced Brunner & Mond the not inconsiderable sum of £5,000, which was of key importance in ensuring the early financial sustainability of their enterprise at Winnington Hill. This overdraft facility for up to £5,000 proved to be insufficient for Brunner and Mond's immediate credit needs, and the debt spiralled towards the £10,000 mark. Indeed, both men were called into the Parr's Bank offices in order to explain why their borrowings had risen to such a high level. The Parr's Bank Northwich branch manager between 1873 and 1881 was George Wallace Crabb. Had Crabb and the Parr's directors not approved these extended lines of credit, it's doubtful whether the Brunner Mond empire would have expanded quite so rapidly, and the subsequent history of Northwich, and of the British chemical industry as a whole, might have been very different. Parr's Bank expanded throughout the country during the nineteenth and early twentieth centuries, so that by 1918 it had 235 branches and ninety-four sub-branches. In that same year, the directors decided to amalgamate with the London County and Westminster Bank Ltd. After this, the name of Parr's Bank began to disappear from the high streets of Britain. Even so, the merged Parr's Bank still made a key contribution to the development of the modern National Westminster Bank of today.

Plaza Cinema

The former Plaza Cinema on Witton Street, which became a bingo hall between the 1960s and 2011, is surely one of the most distinctive and unusual buildings still to be found in central Northwich. Whereas many of the town's traditional buildings are of black and white timber or terracotta brick, the Grade II listed Plaza boasts an ornate, brightly coloured neoclassical exterior. It also has a sumptuous interior, with a double-sized auditorium and balcony seating of original mottled crushed velvet. The original building was designed for Cheshire County Cinemas Ltd by William and Segar Owen of Warrington, who were architects of distinction and played a significant role in the development of nearby Port Sunlight. The building itself was encased within a steel frame, perhaps as a protection against the subsidence that caused so many other notable Northwich buildings to collapse. The Plaza opened to the public in December 1929 with a showing of the Al Jolson film *The Singing Fool*, and was the first cinema in the town to show a picture with sound, rather than just a silent film. In the

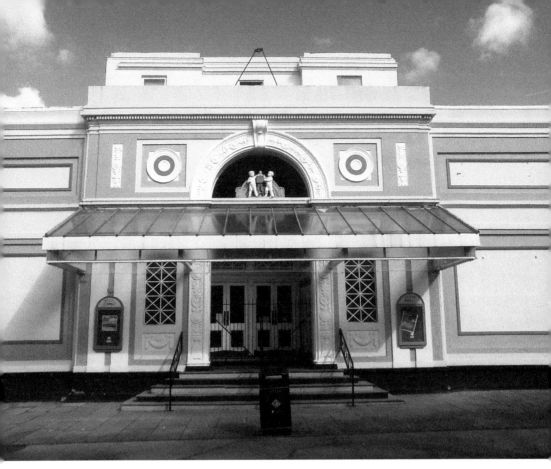

Above: The former Plaza Cinema, completed in 1929.

Right: Interior stained-glass window from the Plaza Cinema. (© Sally Buttifant)

pre-television age when going to the movies was immensely popular and relatively cheap, up to five different cinemas once operated in Northwich, though some lasted much longer than others. By the time the Regal Cinema closed in 2007, none were left. A plush new cinema complex opened in 2016 as part of the Barons Quay development, but it certainly lacks the architectural uniqueness and quirky, opulent interiors of a fabulous old cinema like the Plaza in Witton Street.

The Penny Black

This Witton Street building, now a public house, was originally home to the town's main post office and was constructed between 1914 and 1915 (though the building remained empty until 1919). It has an ornately decorated and ornamented frontage, with three storeys, an attic and a tiled roof. The building itself was constructed using the composite method with timber frames, recessed panelling, steel ring beams and jacking points, which allowed the whole structure to be lifted and moved in the event of subsidence. Once completed, it became the largest liftable building in the town.

The Penny Black.

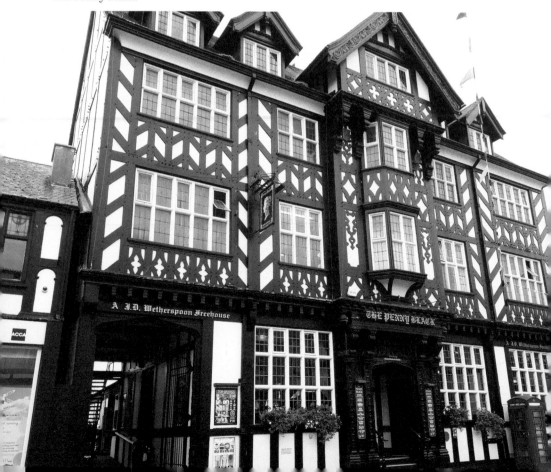

Quality Floatel

For twenty years, between 1989 and 2009, Northwich had its own hotel (or 'Floatel' as it was called) situated on the River Weaver, in the centre of the town, located roughly where the modern marina development can now be found. The hotel used to market itself as being the only floating hotel in the UK, and the building did indeed extend out into the river, constructed on pontoons, in prefabricated sections. The Floatel had sixty bedrooms, a restaurant, and all the usual facilities one would expect of a more conventional land-based hotel. In the mornings residents could wake up to the sound of the river lapping against the base of the bedroom walls. At the height of its

The Quality Floatel on the River Weaver. (Courtesy of Allan Watkins)

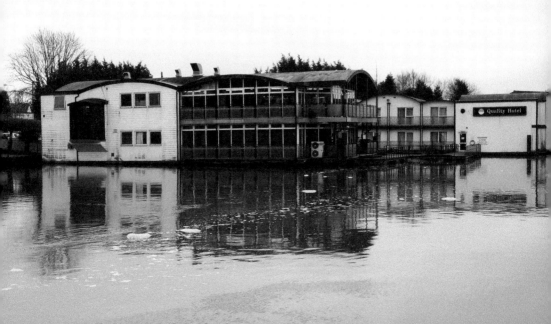

popularity, the place had a certain quirky charm, and perhaps it was rather ahead of its time. Though it closed down in 2009, and the hotel's prefabricated sections began to be dismantled by British Waterways at the end of the same year, similar buildings have since sprung up in places as far apart as Hartlepool and Kent.

Queen Victoria

Although Victoria never visited Northwich as a reigning monarch, she was still honoured by the town in a number of ways. The Verdin Technical Schools and Gymnasium on London Road were built at the time of Victoria's 1897 Diamond Jubilee. As a consequence, the building, designed by Northwich architect Joseph Cawley and funded entirely by the local salt magnate Sir Joseph Verdin, contains some impressive

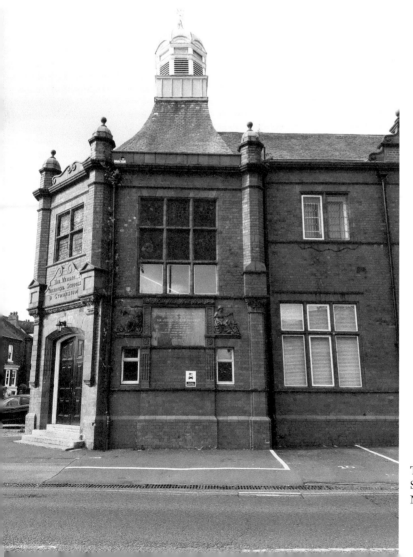

The Verdin Technical School, London Road, Northwich.

Above left: Stained-glass window depiction of Queen Victoria, from the Verdin School, 1897.

Above right: Stained-glass window depictions of Prince Edward and Princess Alexandra, from the Verdin School, 1897.

stained-glass window depictions of Victoria and the Prince and Princess of Wales. Latterly, the building was in use as the Cheshire School of Art & Design, before finally being transformed into a series of private flats and apartments. Queen Victoria also had a local football club – Northwich Victoria – named in her honour. The original club was founded in 1874 and played at the same Northwich Drill Field ground for over 125 years, until it was finally demolished in 2002. Very few other football clubs anywhere in the world have played at the same ground for quite so long.

R

RAOB Building

The RAOB building on Witton Street was built by E. W. Bostock in 1913 and designed by the distinguished architect J. Cawley. The building gets its rather strange name from the Royal Antedeluvian Order of Buffaloes (RAOB), a charitable organisation that occupied the premises between 1977 and 2013. The RAOB, which engaged in good works within the community, was organised rather like a Masonic order, with grand

The RAOB (Silver Jubilee) Building.

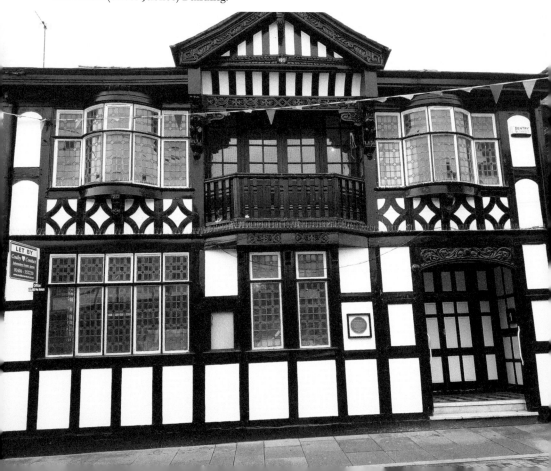

lodges and new entrants who were called either brothers or 'kangaroos'. Long before the RAOB purchased the property, the building was the home of the Constitutional Club and the headquarters of the Northwich Conservative and Unionist Association. The building once had an immense interior, covering over 4,800 square feet, with cellars, saloon areas, function rooms, a viewing gallery and an upper-storey balustrade balcony. All this space is currently being redeveloped into a mixture of commercial and residential properties.

Paula Radcliffe

Paula was born in Davenham on 17 December 1973, but moved to nearby Barnton as a child, where she attended Little Leigh Primary School. The family moved to Bedfordshire when Paula was twelve. Young Paula took up running when she was seven years old, even though she suffered from anaemia and asthma. Despite these obvious health problems, she went on to have a long and glittering career in athletics, becoming the 10,000 metres European women's champion and a silver medallist at the 1999 World Championships. Paula was also the women's 5,000 metres gold medallist at the 2002 Commonwealth Games, and competed at four consecutive Olympic Games between 1996 and 2008 (though she never won an Olympic medal). Paula Radcliffe is

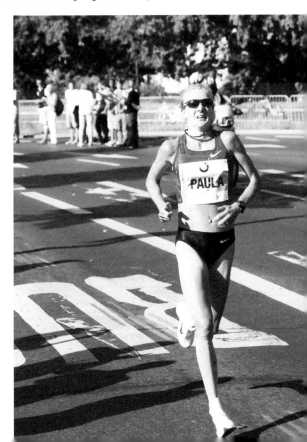

Paula Radcliffe at the Berlin Marathon, 2011. (Courtesy of Ramon Smits)

perhaps best remembered as a legendary marathon runner, winning both the London and New York marathons three times. In 2002, she won the Chicago marathon in a world record time, despite tearing her colon during the race, and in 2003 she beat her own women's world record at the London marathon, completing the race in a time of 2:15:25 (which remains the world record to this day). The Davenham-born star was awarded the MBE in 2002, and finally retired from competitive athletics in 2015.

Elizabeth Raffald

Elizabeth Raffald was born in 1733 in Doncaster, South Yorkshire. However, she started her working life in the kitchens and as a housekeeper at Arley Hall, Northwich. Here she met her future husband, John Raffald, who worked as the estate's head gardener. As employees were not allowed to work at Arley Hall after marriage, the newlywed couple had no choice but to move to Manchester in 1763. It was here that Elizabeth ran a cookery school and an outside catering business. She also wrote a book called *The Experienced English Housekeeper*, which included cooking recipes and culinary advice. This book was a best seller, produced 100 years before Mrs Beeton wrote her more famous cookery and housekeeping advice.

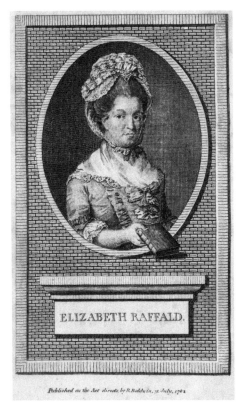

Elizabeth Raffald, 1733–91.

Roberts Bakery

Travellers along the Northwich bypass, both by foot and by car, have long been assailed by the aroma of freshly baked bread as they pass by the Roberts Bakery works in Gadbrook Park. Roberts Bakery is, in fact, a Northwich family business that dates back to Victorian times. The founder of the business was Robert Roberts, who launched his first shop in Castle Street in 1887. At this time, Robert Roberts was a grocer – one of 125 in the Northwich area in 1890 – who was keen to leave grocery behind and expand into the bakery business. In 1894, he participated in a great Angel Hotel sale when whole stretches of property and land along Station Road were put up for sale. Although Brunner-Mond purchased some of the properties, Robert Roberts was able to buy Nos 124–126 Station Road, which became the home of Roberts Bakeries for the next fifty years. By the time of Robert Roberts' death in 1936, the company name had changed to Roberts (Lostock) Ltd, and they'd also acquired the former Middleton's Bakery in Warrington Road. By 1952, the company was trading under the name of Frank Roberts & Sons Ltd. It moved to Gadbrook in the same year, where it remains (within the confines of the modern Gadbrook Park industrial estate) to this day.

Roberts Bakery, Gadbrook Park.

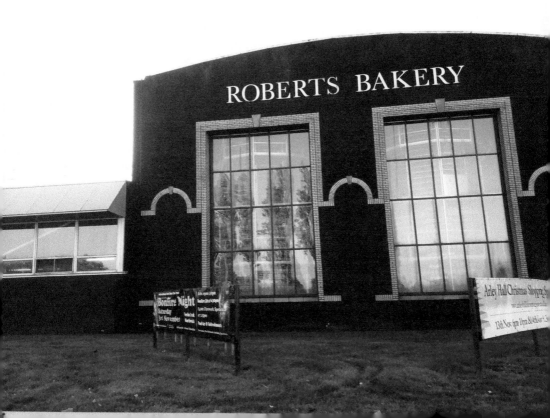

Sir John Deane's College

In 1557, Sir John Deane founded a free grammar school for boys in Witton. Deane was a local boy, born in Shurlach, between Davenham and Rudheath, who enjoyed a successful career in the Church, prospering under both Catholic and Protestant Tudor regimes. However, he wasn't a knight of the realm – in the mid-Tudor period, the title 'Sir' was applied to clerics like John Deane who were in possession of university degrees. The money to launch the new free Witton grammar school came

The 1909 Sir John Deane's school building.

from the profits Deane made from buying and selling former Church lands acquired after Henry VIII's Dissolution of the Monasteries. In its very earliest days the school was closely associated with St Helen's Church and occupied buildings on the church's land. In 1907, on the 350th anniversary of the founding of the grammar school, Sir John Brunner provided sufficient money for the school to move from Witton to its current site by the River Weaver, and the school later became part of the overall state sector. In 1977, Sir John Deane's became Northwich's sixth-form college, and by late 2010 over £28 million had been spent on a college demolition and extension programme. In terms of A-level pass rates and retention levels, Sir John Deane's is ranked regularly among the top ten of English and Welsh sixth-form colleges.

St Helen's Church

St Helen's Church, at the top of Chester Way, is one of the few central Northwich buildings of note to survive the effects of land subsidence. It is by far and away the oldest building in the town, with a history that stretches back to the fourteenth century. The church is a well-known Grade I listed building, often described as the 'Cathedral of Mid Cheshire' and frequently referred to as one of England's finest parish churches. Of course, for most of its history, St Helen's Church has been a chapel of ease rather than a parish church. Chapels of ease were really a subsidiary category of church, providing a place of worship for parishioners unable to get to their main parish church. Until it became a parish church in its own right in August 1900, St Helen's was the chapel of ease attached to the parish church of St Mary and All Saints in Great Budworth. A chapel of ease has been present on the site of St Helen's since the fourteenth century. This chapel was roughly the same size as the modern

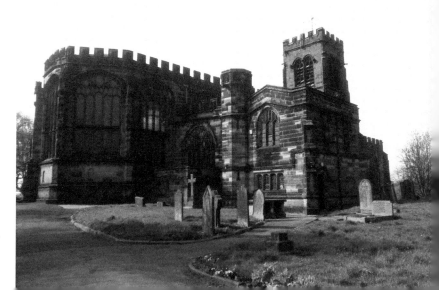

St Helen's Church.

St Helen's Church, but it would have had no aisles and the only seating available was on stone benches situated around the walls. Although some of the fourteenth-century parts of the church are still in view, the church as it currently stands was created mainly through two subsequent phases of construction. During the Tudor period an impressive roof was constructed (the roof over the nave was probably completed by 1550). After this, the church was heavily restored during the nineteenth century, with three spectacular, large, coloured stained-glass windows being installed behind the altar in 1861–62. By the 1890s, most of the key improvements and renovations had already been completed and the architecturally striking church that emerged was very much the church that we see today.

Swing Bridges in Central Northwich

The Hayhurst Bridge (originally called the Navigation Bridge) and the Town Bridge are two of the very first electronically operated swing bridges ever built. Both were designed by Colonel John Sayer and built by Andrew Handyside & Co. of Derby. Yarwood's, the local shipbuilders, also assisted in the construction of the pontoons on which both bridges sit. The Hayhurst was completed first, in 1898, though the Town Bridge soon followed in 1899, and after Mather & Platt Ltd had completed the electrical works both bridges were officially opened on 20 July 1899.

Northwich Town Bridge.

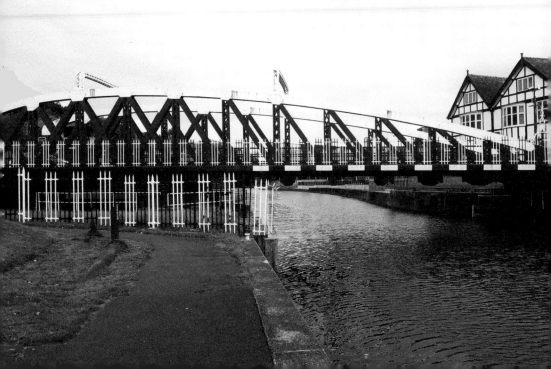

T

Terracotta Thompson

Jabez Thompson, born in 1838, was the son of John and Mary Thompson. John was one of the most powerful business figures in mid-nineteenth-century Northwich, with significant salt, brickworks and shipbuilding interests. John Thompson died in 1867, leaving his various businesses split between his different sons. Jabez inherited his father's brickmaking works, principally situated on Manchester Road, Northwich (and which began brick production way back in 1824). From this point onwards, Jabez became more and more focused on the expansion of his brickmaking business,

Stamped Jabez Thompson brick. (© Weaver Hall Museum)

eventually producing common, fine and moulded bricks, together with terracotta works, which were known throughout Britain. Although in his 1871 census returns Jabez was described as being a 'Salt Officer', brickmaking was rapidly becoming his major preoccupation. In 1870, Hesketh's Corn & Bone Mill was built in Wincham. The mill included a substantial complex of buildings, including an engine house, boiler house, a two-storey bone mill (with warehouse) and a three-storey corn mill. A detached 75-foot chimney was also constructed, and everything at the site – mills, houses and chimney – was made of Jabez Thompson's distinctive-looking red bricks. The bricks were red in colour because of the high proportion of iron oxide found in the original clay used, and the resultant reddish tinge gives many of the old buildings dotted around Northwich their distinctive look, even today. By the 1880s, Jabez was producing bricks for John Douglas, the distinguished Cheshire architect. In addition to this, in 1887 Jabez's company completed a substantial order for 177,000 bricks from Brunner Mond for a new chimney at their Winnington site. His bricks were also used to build the Bridge Inn and the Verdin Technical Schools in Northwich, along with the Moseley Road baths in Birmingham, baths and washhouses in Sunderland and premises in Poland Street and Berwick Street, London. Jabez Thompson's common, fine and moulded bricks were being exported around the country, with the fine and moulded bricks all being stamped with the owner's name. It is for his focus on fine ornamental terracotta work that Jabez Thompson is becoming increasingly revered. Terracotta literally means 'fired earth' and it was a type of masonry made of moulded clay which was mostly larger than brick and of a finer quality. Northwich is graced by numerous examples of Jabez Thompson's artistic terracotta works, including the lions' heads at the Lion Salt Works and the classical Greek depictions of learning at the Verdin Technical Schools on London Road. St Michael's & All Angels Church in Little Leigh also hosts Jabez's alto-reredo (altarpiece) reproduction of Da Vinci's *Last Supper* scene. Other examples of his work have been lost. For instance, Jabez's Terracotta Works produced special terracotta designs for the façade of the Gladstone

Thompson terracotta work from 1901.

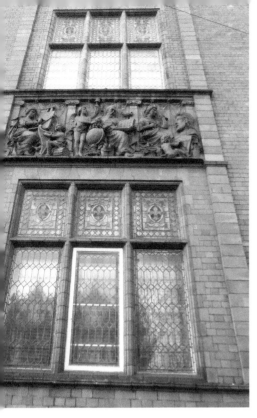

Above left: Thompson terracotta work, in the classical style, from the Verdin Technical School, Northwich.

Above right: Decorated Thompson Science & Art entrance to the Verdin School.

Right: Thompson brickwork above a Weaver Hall Museum doorway.

Jabez Thompson Salt Museum brick sign, 1889. (© Weaver Hall Museum)

Club, opened in 1890, and on a site now occupied by the modern Brunner Court. The Northwich Free Library, opened with much fanfare by the Duke and Duchess of Westminster in 1885, also possessed a special terracotta frontage designed by the Thompson Terracotta Works, which was subsequently lost when the building was demolished.

Ann Todd

Ann was a local girl, born in Hartford in 1907. She was born into a well-to-do, middle-class family. Her father was a sales manager from Aberdeen, and her mother, Constance, was a Londoner. At the height of her fame, between the 1930s and the 1950s, she was a major film star in both Britain and Hollywood. She studied drama at the Central School of Speech and Drama, and had her first speaking part in a film in 1931. Throughout the 1930s she starred in a number of films produced by film mogul Alexander Korda, and in 1934 she returned to Northwich to film a scene in the movie *The Return of Bulldog Drummond* (playing Drummond's wife). Her big break came in 1945 when she starred in *The Seventh Veil* alongside legendary actor James Mason. This was a great success and it gave her a lucrative Hollywood contract

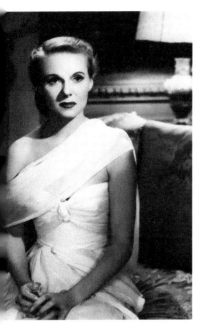

Above left: Ann Todd, 1948.

Above right: Ann Todd and David Lean landing in Germany in 1952. (Courtesy of Harry Pott)

worth over $1 million. She was compared to the legendary Swedish actress Greta Garbo because of her ice-blonde beauty, and this led to her being cast as the lead in a film called *The Paradine Case* directed by Alfred Hitchcock. Ann married three times, and her last husband was the renowned film director David Lean of *Lawrence of Arabia* fame, for whom she appeared in a number of films including the 1950 period piece *Madeleine*. There were many different facets to Ann Todd's career. She was, for example, an accomplished classical actress, completing many of the leading female Shakespearean roles during a complete season with the Old Vic Theatre Company in 1954–55. Ann also developed a highly successful career as a travel writer and documentary producer, and she appeared in many television productions (on both sides of the Atlantic) between the late 1930s and the early 1990s. Ann died in London in May 1993. She had always been popular in America, and US theatre critic William Glover summed up the feelings of many when he said she had been a 'real peaches and cream stunner' of an actress.

Unions

Both workers and employers in Northwich's substantial salt industry formed unions to protect and enhance their interests. The working conditions of a male 'Lumpman' in a nineteenth-century Northwich salt mine were certainly tough, with shifts of between 80 and 90 hours a week (often involving strenuous physical activity) not uncommon. As a consequence, many local workers united to form a trade union in November

Northwich salt, alkali and labourers union banner. (© Weaver Hall Museum)

1888, called the Northwich and District Amalgamated Society of Salt Workers, Alkali Workers, Mechanics and General Labourers. This later became the more manageably titled Chemical Workers Union. While Northwich salt workers were forming a union to defend their rights and position, Northwich salt mine owners were doing much the same thing. In 1888, at a meeting in the Adelphi Hotel, Liverpool, Northwich and Cheshire salt mine owners were the driving force behind the setting up of the Salt Union. This Salt Union purchased most of the privately owned Northwich salt works, in an effort to prevent price undercutting and competition. Within ten years or so, it was clear that this Salt Union had been a failure, damaging the Northwich salt trade and boosting competition from abroad.

Union Bank of Manchester

The Union Bank of Manchester is a name that has been absent from the Northwich High Street for many decades. It originated in Manchester in 1838 during the era of 'cottonopolis' when cotton was king and the city was at the heart of the Industrial Revolution. The bank established its first branch outside Manchester, in Knutsford,

The Union Bank of Manchester, 1922. (© Barclays Group Archives)

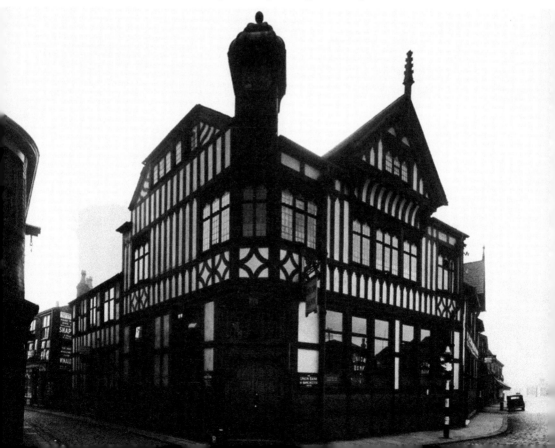

in 1856. Soon after, in 1863, the Union Bank established its first branch in Northwich, located at No. 1 Castle Street, where it stayed for nearly sixty years until it purchased new premises in Imperial Buildings, in the Bull Ring, in 1921. By this time the Union Bank had been an affiliate bank of Barclays for two years, though it kept its separate name and management systems until it was incorporated fully within Barclays in 1940. The tall black and white building where the Union Bank made its home in the early 1920s is still there today, occupied by an estate agency. Immediately next door is the National Westminster Bank, which moved onto the site formerly occupied by the Angel Hotel in early 1925. The process of buying the Imperial Buildings premises at the Bull Ring was not without its problems. The Angel Hotel, next door, had to be demolished as a result of severe subsidence problems, and it was easy to believe that these problems could spread to the Union Bank. The Board of the Union Bank had originally approved the purchase of the Imperial Buildings for the sum of £5,500 in May 1921. Nearly £1,000 was also spent on purchasing two additional cottages immediately behind the new bank premises. However, the Union Bank was still, perhaps not unreasonably, concerned about the risk of subsidence. The Northwich Salt Compensation Board offered the Union Bank £450, presumably to compensate for the potential risk of subsidence, as well as any damage and inconvenience caused by the demolition of the Angel Hotel next door. This initial offer was rejected, but a higher compensation sum of £550 was accepted by the bank, and the planned move went ahead during 1922. The new Union Bank of Manchester branch, in the Imperial Buildings, continued to operate without major problems until its name disappeared from the Northwich Bull Ring forever in 1940. The Barclays branch that took over from the Union Bank stayed at the same Imperial Buildings location for over forty years, until it moved to a new site further up High Street in the 1980s.

V

Joseph Verdin

Joseph Verdin was born in Witton, Northwich, in 1838. He ran a family salt business with his two brothers, which had been founded by his father and uncle. Joseph and his brother owned six salt plants in Cheshire – three of them in Northwich. At its height in

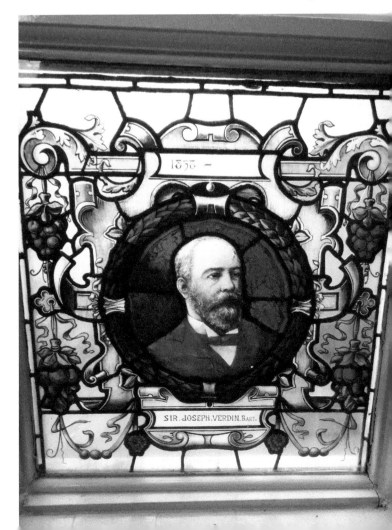

Joseph Verdin, from the Verdin Technical School, 1897.

1881, Verdin's salt business employed over 1,000 people and produced approximately 350,000 tons of salt a year, which made his business the largest producer of salt in the UK. When the emergence of the Salt Union in 1888 brought an end to his salt business, Joseph continued to live in Cheshire, but moved to Herefordshire by 1900, where he lived with his sister Mary until his death in 1920. Joseph Verdin was a great benefactor to Northwich, creating the Verdin Trust in 1889 to compensate people for subsidence caused by brine pumping in the salt industry. Joseph never married and used his wealth to benefit the town of Northwich in a number of ways. The Technical School, on London Road, and the Moulton Institute, were funded by Joseph Verdin and he became a JP, deputy lieutenant and county alderman for Cheshire. He also became a baronet in 1896 and was knighted the following year.

The Victoria Infirmary

This small hospital sitting at the top of Winnington Hill has been receiving patients since it first opened its doors back in 1887. Before it took on its present guise as a hospital, the building had formed part of the Winnington Bank mansion and estate

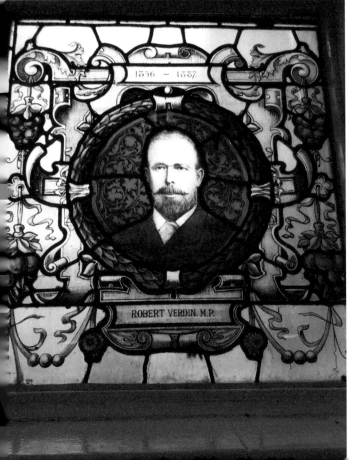

Robert Verdin, from the Verdin Technical School, 1897.

owned by Thomas Hostage, a local lawyer and clerk to the Trustees of the River Weaver. In 1887, both the mansion and the estate were put up for sale at auction and bought by Robert Verdin, the elder brother of Joseph Verdin and a key member of the extremely wealthy local Verdin salt family. Robert was Northwich's MP at the time of the purchase. The land adjoining the original mansion was given to the town by the MP so that it could be transformed into Northwich's new municipal park, while the mansion itself was turned into the hospital. Robert Verdin died in the very same year that he made the bequests, and neither the park nor the hospital had been officially opened by the time of his death. Since its opening, the infirmary has been altered and expanded on many occasions. In 1902, a new wing was added and there were further extensions in 1905. An Orthopaedic Clinic was opened in 1919, and a children's ward followed in 1924 (along with further additions in the 1930s). The infirmary joined the NHS in 1948 and currently acts as a Minor Injuries Unit, with Therapy and Outpatient Services.

River Weaver

The story of the development of the River Weaver for trade purposes is a long one, going back to at least the mid-seventeenth century. However, the first major parliamentary Act that allowed for the Weaver's development only came about in 1721. Even then, the three local gentlemen given the chief responsibility for 'undertaking' the scheme did very little. It wasn't until late 1729 when the two brothers Thomas and Jonathon Patten, together with Thomas Eyre and John Dickenson, took over responsibility for

River Weaver at Winnington. (Courtesy of ReptOn1x)

River Weaver from Town Bridge, Northwich.

developing the Weaver's navigable capacity that some real momentum and drive was provided. Between late 1729 and the beginning of 1732, the four men ensured that the substantial sum of over £20,000 had been invested in widening and deepening the river, and providing the other related facilities necessary for a burgeoning commercial waterway. By January 1732, the operators of the newly expanded Weaver were recouping some of their investment by charging revised tolls on barges travelling along the river. Even so, despite the tolls, the enhanced Weaver Navigation had a significant effect in reducing the cost of transporting Cheshire salt to the local ports. This made Cheshire salt much more competitive in the export market, and Northwich itself was dominant in this trade – a dominance shown by the fact that in the 1740s three-quarters of all the traffic on the 50-mile-long River Weaver was going either to or from the town of Northwich. In the 1750s, two of the greatest local landowners, Sir Peter Leicester and Sir Peter Warburton, launched yet further improvements to the depth and width of the Weaver, which gave a massive boost to the Northwich salt trade. By the early 1770s, over 82,000 tons a year of salt was being shipped down the Weaver, on its way to countries across the world, including Ireland, the Baltic states, Jamaica and America. Northwich salt was pre-eminent in this worldwide trade, and remained so for the next century. In 1880 alone, over 1 million tons of this precious commodity was being shipped along the Weaver, making the river one of the busiest maritime highways in the country.

Weaver Hall Museum

The museum, on London Road, was once the location of the Northwich Union Workhouse, built by George Latham in 1837. The workhouse was once a refuge of last resort for the poor and needy of Mid Cheshire. Once the building had ceased to be a workhouse it was utilised (between 1946 and 1968) as a home for the elderly, and much of the original workhouse structure was demolished. Only the original frontage remained, and even this came under threat when the home for the elderly was finally shut down. However, in 1977 the remaining structure was saved, largely due to the efforts of the author Robert Westall, and the Grade II listed building evolved into the museum it is today. It has displays and exhibits that shed light on the daily routines and diet of the workhouse inmates once housed there. The Guardians' boardroom, where weekly meetings were held to discuss inmate care, has also been reconstructed with considerable attention to detail. Upstairs, there are displays and exhibitions devoted to the history of salt, shipbuilding and soda-ash production in Northwich.

Weaver Hall Museum.

Rear of the Weaver Hall Museum.

Robert Westall

Robert Atkinson Westall was born in North Shields, Northumberland, on 7 October 1929. After obtaining a BA degree at Durham University, he completed his obligatory two years of national service in the Royal Corps of Signals between 1953 and 1955. He pursued further postgraduate studies at the Slade School of Art in London after leaving the army, and undertook teaching jobs in Birmingham and Yorkshire in the late 1950s. In 1960, Robert Westall's long association with Northwich finally began when he applied successfully for the position of Head of Art at Sir John Deane's Grammar School (now the sixth-form college). He stayed at Sir John Deane's for the rest of his teaching career, becoming Head of Careers in 1970, before finally retiring in 1985. It was while teaching at Sir John Deane's and living at No. 20 Winnington Lane that Robert wrote his first children's novel (handwritten in school exercise books) called *The Machine Gunners*, which was published in 1975. The book, which was about a group of children who discover a Second World War German bomber plane in the woods, together with its intact machine gun, was an immediate success around the world. Over fifty subsequent books were forthcoming, some of them published after Westall's death in 1993. He wrote non-fiction and autobiographical works as well as his children's novels, and the stories were translated into over seventeen different languages. Westall's worldwide impact was immense. The American Libraries Association described his book *Blitzcat* as being one of the best 100 books produced in the world for young adults between 1969 and 1994. Elsewhere in the world, Westall helped inspire the work of the famous Japanese animator

Hayao Miyazaki. Very few novelists are lucky enough to win the prestigious Carnegie Medal for literature. Westall, however, won the award twice: firstly for *The Machine Gunners* in 1975 and secondly for *The Scarecrows* in 1981. He also received a range of other literary prizes and commendations in what turned out to be a prolific and glittering writing career. Despite this worldwide literary adulation and fame, Westall seems to have led a down-to-earth, normal life. After retiring from Sir John Deane's in 1985, he developed a thriving antiques business, which ran under the name Magpie Antiques, and operated from a shop at the junction of Church Lane and London Road, in Davenham. Westall also attended a writers' circle meeting in nearby Lymm, where he would pass on advice and tips to other aspiring writers. Robert Westall's personal life was certainly touched by great tragedy. He often stated that his only son, Christopher, was the main inspiration behind his burgeoning storytelling skills – he would tell Christopher all about his wartime experiences in the north-east, and it was from these oral reminiscences that later ideas for novels would emerge. Sadly, Christopher's life was cut short, aged eighteen, as the result of a motorcycle accident. Later, Westall's wife, Jean, also committed suicide. Despite these great personal traumas, Robert Westall kept on writing and he produced a varied body of works, which will continue to be read and admired by children, adolescents and adults across the world for many generations to come.

The building once occupied by Robert Westall's Magpie Antiques, at the junction of Church Street and London Road, Davenham.

X

Itinerary X

The first references to Northwich are found in Roman sources, when the settlement was known as Condate. The name 'Condate' probably derives from a Latinised version of a Celtic word meaning 'confluence' or 'junction', which is indicative of the fact that the first settlement lay near the junction of the River Weaver and the River Dane. Over 1,700 years ago, during the third century CE, the Roman Antonine Itinerary road map was produced and split into fourteen sections. Itinerary X of the road map described a route between Glannoventa (modern Ravensglass in Cumbria) and Medialanum (Whitchurch in Shropshire). Along this section of the map, the fort and settlement of Condate is identified as being 19 Roman miles before the end of the route at Medialanum, and 18 miles from Mamucium (now Manchester).

Xmas Day at the Northwich Workhouse

According to at least some press reports of the time, Christmas Day at the Northwich Workhouse, roughly 120 years ago, was really rather good. For example, on 28 December 1891, the *Liverpool Mercury* newspaper reported that the Northwich Workhouse inmates had had 'high jinks' on Christmas Day, enjoying a Christmas dinner with copious amounts of roast beef and vegetables, followed by plum pudding. Beer was also available for those that wanted it. Nine years later, at the end of December 1900, the *Manchester Courier* newspaper reported that 2 hundredweights of ingredients had been mixed together to provide a plentiful supply of Christmas dinner for the Northwich Workhouse residents. The newspaper report described the Board of Guardians members (who ran the workhouse) as 'vying with one another' to look after the interests of all 180 residents. Moreover, Santa Claus actually visited the children's ward of the workhouse, supplying gifts of oranges, sweets and toys. Gifts of packets of tea for the adult female residents, and tobacco for the men, were also given. Two years later, during Christmas 1902, the *Manchester Courier* observed that Santa Claus had again made a visit to the workhouse children on Christmas Eve, filling their stockings with toys, sweets and fruit. Christmas carols were also sung by the inmates (including thirty-five people aged seventy or above)

and the old eighteenth-century hymn 'Christians Awake', written by John Byron, had proved to be a particular favourite. The inmates were also reported to have decorated parts of the workhouse, in festive fashion, for themselves. This cheery depiction of life in the Northwich Workhouse at Christmastime is undoubtedly a rather fanciful one. Many strict workhouse rules were still in place. For example, there was segregation of the sexes, though regulations were in place allowing couples aged sixty or above to share a room. Children were also kept apart from their parents. When Northwich Workhouse was built in 1837, the national rules enforced by the Poor Law Commissioners prevented any extra expenditure on food at Christmastime, or on any other feast days. By the end of the century, the national regulations had been relaxed somewhat and extra Christmas treats for the inmates were allowed, using workhouse funds. Even so, the major Northwich Workhouse treat for its inmates was still just the provision of a Christmas Day dinner, of the sort described by the *Liverpool Mercury* newspaper in 1891. Other Christmas gifts were usually donated by well-to-do local women, and some of these gifts could be substantial. In 1885, Mrs Macrae of Hartford gave the inmates a Christmas tree laden with gifts for the workhouse children. The same woman supplied every female inmate of the workhouse with a quarter pound of tea and 1 pound of sugar, and every man was given 2 ounces of tobacco. Mrs Macrae's largesse also extended to supplying every inmate with oranges and buns. By the 1920s, Santa Claus was a visitor at most workhouses across the country. Funds to support Santa's gift giving, at Northwich and elsewhere, probably came from a combination of workhouse sources and private donations. Press reports in 1891 that Northwich workhouse festivities were washed down with beer, might be open to question. The temperance movement was quite strong around the country in the 1870s and 1880s, and in 1884 the Local Government Board decreed that workhouse masters would have to pay out of their own pockets for any alcohol consumed within the workhouse that was not supplied under medical instruction. If the Northwich workhouse inmates were drinking alcohol, then it was at the master's own expense.

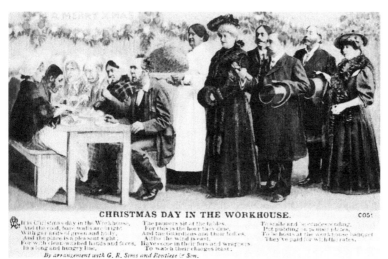

'Christmas Day in the Workhouse', from a George Robert Sims ballad of 1877.

Y

Yarwood and Pimblott

Shipbuilding was a thriving industry in Northwich for over 250 years. At one time or another during this period as many as thirty independent shipyards once lined the banks of the River Weaver. Most of these concerns were small one-man businesses building 'flats' for the transportation of salt, but two shipbuilders – W. J. Yarwood & Sons and Isaac Pimblott – grew to become major businesses, supplying vessels to customers all over the world. Yarwood's was the biggest shipbuilder, with a site covering 9 acres near Navigation Road in central Northwich, at the premises once occupied by Woodcock and Thompson. William Yarwood was a time-served blacksmith and former apprentice to an ironfounder who launched his shipbuilding business in 1896. He quickly built a reputation for supplying vessels of good quality and considerable workmanship. William's four sons took over the business in 1926, and the shipyard continued to grow from strength to strength. The yard produced some notable ships, including the *Aquarius* in 1936, whose construction was personally observed by T. E. Lawrence 'of Arabia'. This ship, built for the Air Ministry, was later sunk by the Japanese following their attack on Singapore, and may have been acting as a spy ship. In 1946, the yard also built the *Davenham*, the last steam-powered ship ever produced for the ICI fleet. The United Molasses company took over Yarwood's in 1945, but shipbuilding at the Northwich yard continued until 1965. By the time of its final closure, over a thousand vessels, of all types, had been produced by this famous Northwich shipbuilder.

Isaac Pimblott, born in Northwich in 1844, developed the other great shipyard. Pimblott began work as a ropemaker in Wincham at the very young age of nine. He later worked as a boilermaker and in the local salt mines, before moving to work in the Liverpool shipyards when he was nineteen years old. It was his experiences in Liverpool that inspired Pimblott to return to Northwich and set himself up as an independent shipbuilder based on the River Weaver, near Hayhurst Bridge. From 1906 onwards, the Pimblott yard moved beyond Hunt's Lock towards the Hartford manor area. Although Isaac died in 1906, Pimblott's continued to produce a range of ships that saw service across the globe; for example, the yard developed one of the first steamers to cross the Atlantic to South America. In later times, the Pimblott ship *Montford* was involved in the Biafran War in Nigeria, and the *Royal Governor* became part of the Royal Navy's Northern Ireland patrol squadron during the 1970s and 1980s. The Pimblott company finally ceased trading as a shipbuilder in 1971.

The engine from the
Anderton – a Yarwood's vessel.

Left: Model of the *Davenham* –
the last steamship made at
Yarwood's, for the ICI fleet, in
1946. (© Weaver Hall Museum)

Below: Pimlott's shipyard
(post-1906). (© Weaver Hall
Museum)

Above: The *Paradine*, launched from Pimlott's in January 1952. (© Weaver Hall Museum)

Below: The *Snipe* – one of the smaller vessels launched at Pimlott's. (© Weaver Hall Museum)

Z

Zeppelin

On 12 April 1918 a group of five Zeppelin airships attacked eastern England on a bombing raid. One of the airships, L61, carried on deep into England, heading westwards (probably on a mission to bomb Liverpool). However, the airship, commanded by Herbert Erlich, was driven severely off course by high winds and anti-aircraft fire, and appeared high over Cheshire at some point during the evening of 12 April. The droning noise of the Zeppelin caused some alarm among the population below. Ethel Barrow, a teenager who lived in Lostock Gralam with her mother and siblings, clearly remembered watching the Zeppelin flying overhead and could still recall the incident many decades later when she was reminiscing about her youth in Northwich. Erlich's airship didn't bomb Northwich, but at around 11 p.m., the Zeppelin dropped its first bomb in nearby Warrington. Another bomb landed in a farmer's field at Bold, and further bombs were dropped on Wigan. In all, nineteen bombs were dropped, eight people were killed, and nineteen injured. Northwich had had a lucky escape. In these early days of aerial warfare, navigation methods were very crude. Once Erlich had returned safely to Germany, he apparently believed he had attacked Sheffield rather than Warrington and Wigan. Clearly, it could very easily have been Northwich that suffered instead!

Wrecked First World War German Zeppelin LZ59.

WAR

Bibliography

Armstrong, E. F., *Nature: International Journal of Science*, 30/09/1944.

Barlow, G., *Gary Barlow: A Better Me* (Blink Publishing, 2018).

Bebbington, G., 'Remember When: Flood Disaster Remembered', in *Northwich Guardian*, 28/02/2015.

Bevan, R. M. *The I.C.I. Affair: Cheshire's Most Sensational Murder Mystery* (C.C. Publishing: Chester, 2017).

Bishop, P., *Bomber Boys: Fighting Back 1940–1945* (Harper Press, 2007).

Bostock, Tony, *Owners, Occupiers and Others: Seventeenth Century Northwich* (Anne Loader Publications, 2004).

Environment Agency, 'Northwich Flood Risk Management Scheme Officially Opened', press release, 17/07/2017.

Fielding, A. M. and A. P. Fielding (eds), 'Research Report No. 2: Salt Works and Salinas' (Salt Works Trust, 2005).

Foster, Charles F., *Capital and Innovation: How Britain Became the First Industrial Nation. A Study of the Warrington, Knutsford, Northwich and Frodsham Area 1500–1780* (Arley Hall Press, 2004).

Lavell, P., 'Historical Notes on the Site of the Former Parr's Banking Company Premises at Danebridge, Northwich' (CRS Consultants Ltd, June 2015).

Lynch, Colin James, *Colin Lynch's Northwich* (C.C. Publishing: Chester, 2004).

MidCheshire Community Rail Partnership, www.amazingwomenbyrail.org.uk (2018).

Mottershead, June. *Our Zoo: The Real Life Story of My Life at Chester Zoo* (Headline Publishing Group, 2014).

National Heritage List for England, www.historicengland.org.uk.

Northwich Townscape Project, www.northwich-th.co.uk.

Sharp, R., 'Polythene's Story: The Accidental Birth of Plastic Bags', in *The Independent*, 26/03/2008.

UCL, 'Summary of Individual Legacies of British Slave Ownership', www.ucl.ac.uk.

Acknowledgements

Sally Buttifant for permission to use photographs of stained-glass windows from the Plaza Cinema.

The Catalyst Museum, Widnes, for permission to use photographs of Gustav Jarmay and the Brunners.

Cheshire Constabulary.

Dirk Frater at the Ethel Barrow Medical Centre, Texas, for permission to use the photograph of his grandmother, Ethel.

Friends of Weaver Hall Museum for organising a series of informative talks on the Anderton Boat Lift, Northwich shipbuilding, and the history of the chemical industry.

Chris Mundy at the Salty Dog, Northwich.

Clive Steggel and the staff of CRS Consultants for an illuminating tour of their premises and an in-depth explanation of the Parr's Bank renovations.

Weaver Hall Museum staff for their help in securing access to Jabez Thompson terracotta exhibits, salt exhibits and the Pimlott photography archive.

Nicholas Webb at Barclays Group Archives.

St Wilfrid's Church, Davenham.

George and Jo Williams for permission to use photographs from their Geraldine Allen collection.

Every effort has been made to fulfil requirements with regard to reproducing copyright material. The authors and publisher will be glad to rectify any omissions at the earliest opportunity.

About the Authors

Adrian L. Bridge was born a few miles to the north of Northwich, in Bucklow Hill, and has taught history in various further education and higher education institutions since the 1980s. Since retiring as a senior history lecturer, Adrian has written extensively on both educational and historical issues, and continues to work as a senior assessment specialist in history for the Cambridge Assessment wing of the University of Cambridge. Dawn Preece, originally from Stoke, moved to Northwich after completing a history degree, and is a specialist in women's history and genealogical research. She has produced and delivered exhibitions on *Hidden Women of Cheshire*, and has made significant written contributions to the on-line *Amazing Women by Rail* project.